LIVES OF THE GREAT ARTISTS

GIOTTO LEONARDO DA VINCI ALBRECHT DÜRER MICHELANGELO
RAPHAEL TITIAN HANS HOLBEIN THE YOUNGER EL GRECO CARAVAGGIO
ARTEMISIA GENTILESCHI GIAN LORENZO BERNINI DIEGO VELÁZQUEZ
REMBRANDT FRANCISCO DE GOYA JACQUES-LOUIS DAVID J.M.W. TURNER
EUGÈNE DELACROIX ÉDOUARD MANET CLAUDE MONET VINCENT VAN GOGH

Thames & Hudson

CHARLIE AYRES

This book is dedicated to Malachy,
a great young artist

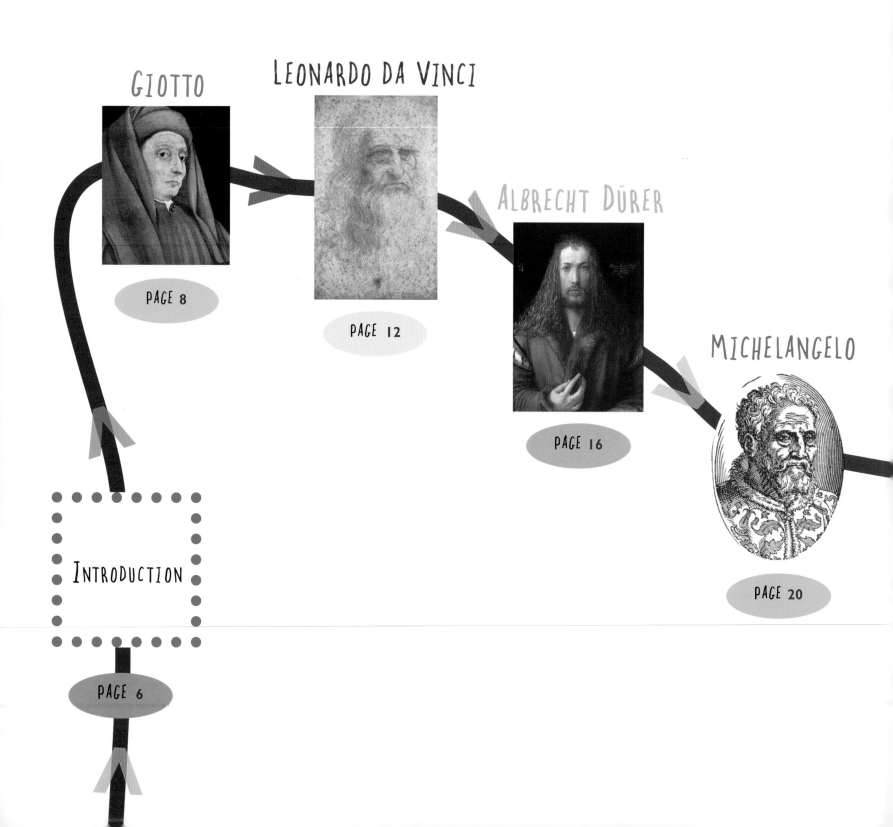

GIOTTO

LEONARDO DA VINCI

ALBRECHT DÜRER

MICHELANGELO

INTRODUCTION

LIVES OF THE GREAT ARTISTS

RAPHAEL

TITIAN

HANS HOLBEIN
THE YOUNGER

EL GRECO

CARAVAGGIO

ARTEMISIA GENTILESCHI

J.M.W. TURNER

EUGÈNE DELACROIX

ÉDOUARD MANET

CLAUDE MONET

VINCENT VAN GOGH

INTRODUCTION

THIS BOOK brings to life the lives and works of some of the greatest artists of the last seven hundred years. It takes you into their studios and workshops so you can smell the paint and hear the noise of marble being chipped away. You can witness the flick of ARTEMISIA GENTILESCHI'S paintbrush, watch the secretive quill-strokes of LEONARDO DA VINCI, hear MICHELANGELO'S chisel, and experience ALBRECHT DÜRER'S printing press in action. This book takes you back to when each work of art was first created, and looks at why each artist made their work, who they made it for, and whether or not they were pleased with it.

We are used to seeing paintings and sculptures in museums and art galleries, but most of them were not made for these places at all. They were made for churches and cathedrals, palaces and private homes. Rich and powerful people asked artists to paint pictures of Bible stories to show how religious they were, or they asked for other stories that showed love or courage. They also wanted pictures of their land, their buildings and their families, to show how much they owned and what fine clothes and jewels they had.

This book explores the lives of twenty of Europe's most talented artists. It starts in the thirteenth century with the Italian artist GIOTTO, who painted people and places as realistically as he could, unlike other artists of his day. It journeys through time to end in the nineteenth century with CLAUDE MONET and VINCENT VAN GOGH, who painted outdoors in a quick and sketchy style, creating an 'impression' of what they could see. It reveals the differences and similarities between many of the artists included. For example, LEONARDO DA VINCI and MICHELANGELO

were both fascinated by the human body, to the point where they repeatedly cut up dead people to look inside. They did this to find out how a body was put together so they could paint and sculpt people more accurately. REMBRANDT spent his whole life painting portraits of people – their outsides, not their insides – and made a lot of money doing so. Before photography was invented in the nineteenth century, asking an artist to paint a portrait was the only way you could have a picture of your mother or father, your children or yourself on the wall.

REMBRANDT also painted lots of pictures of himself, called self-portraits, to show how good a painter he was. People could compare the picture with what the artist actually looked like when they visited him at his studio. Other artists painted themselves as well. DIEGO VELÁZQUEZ included a portrait of himself in his famous painting of the Spanish royal family, *Las Meninas*, and ALBRECHT DÜRER painted himself looking like Jesus. VINCENT VAN GOGH painted his self-portrait after he cut off part of his ear.

Quite a few artists did dangerous things for their art. J.M.W. TURNER stuck his head out of a speeding train and had himself strapped to the mast of a ship to experience storms up close. Other artists, including CLAUDE MONET, painted outside at all times of year, even if it was raining, snowing or foggy.

Lots of famous paintings and sculptures are illustrated in this book, and there is information at the back that tells you where you can see the real works of art. Many of them are now in museums and galleries, and you can go and visit them. But this book attempts to place them back in time, at the moment each artist finished working on them. It gives you a unique insight into how and why these works were made, as well as telling you stories about each artist. As you get to know each one, you may even find yourself stepping into their shoes. I'd just avoid MICHELANGELO'S boots if I were you. He used to keep them on for so long that, when he took them off, sometimes his skin came off too. How pleasant!

CHARLIE AYRES

GIOTTO

Giotto di Bondone (1267–1337) is known as the father of Western art. He was the first artist since classical times to give his figures a life of their own and make them seem real. He was much in demand for his cycles of paintings, which decorated entire chapels and churches.

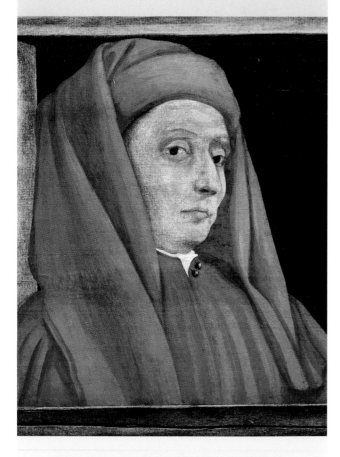

Portrait by the Florentine Painting School, mid-16th century

Giotto lowers his eyes from the star-studded ceiling of the **Arena Chapel** in Padua, northern Italy, and looks around the room. He has just finished painting stories about Jesus and Jesus's mother Mary all over the walls. Giotto has been working here for two years, ever since Enrico degli Scrovegni asked him to decorate the new chapel. It stands on the site of an old Roman arena, hence its name. Enrico had it built next to his family palace, which he is now renovating. From the outside the chapel seems very humble, built in pink brick with modest windows. But inside it is gloriously colourful. Giotto has covered every wall with stories that link together like pictures in a cartoon strip.

Giotto turns to look at one of his paintings. It shows the Holy Family's **Flight into Egypt**. The painting reminds Giotto of his own wife and eight children. They live in Florence, which is a long way away. Giotto had to leave his family behind in order to design and paint the Arena Chapel in Padua. He has lived all over Italy, from Rome to Assisi, moving to where the work is.

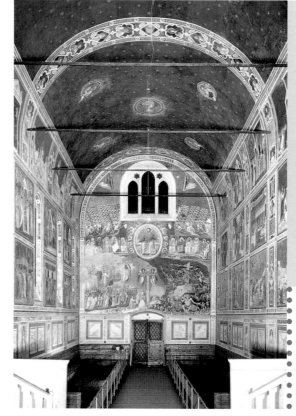

The Arena Chapel

Giotto painted on the walls by coating them in plaster and painting while the plaster was still wet. This technique is called 'fresco'. It helps preserve the painting on the surface of the wall. It was becoming fashionable in Giotto's day because it was quicker, cheaper and more flexible than traditional mosaic decoration.

WHY DON'T YOU?
Tell a story in pictures by drawing a cartoon strip.

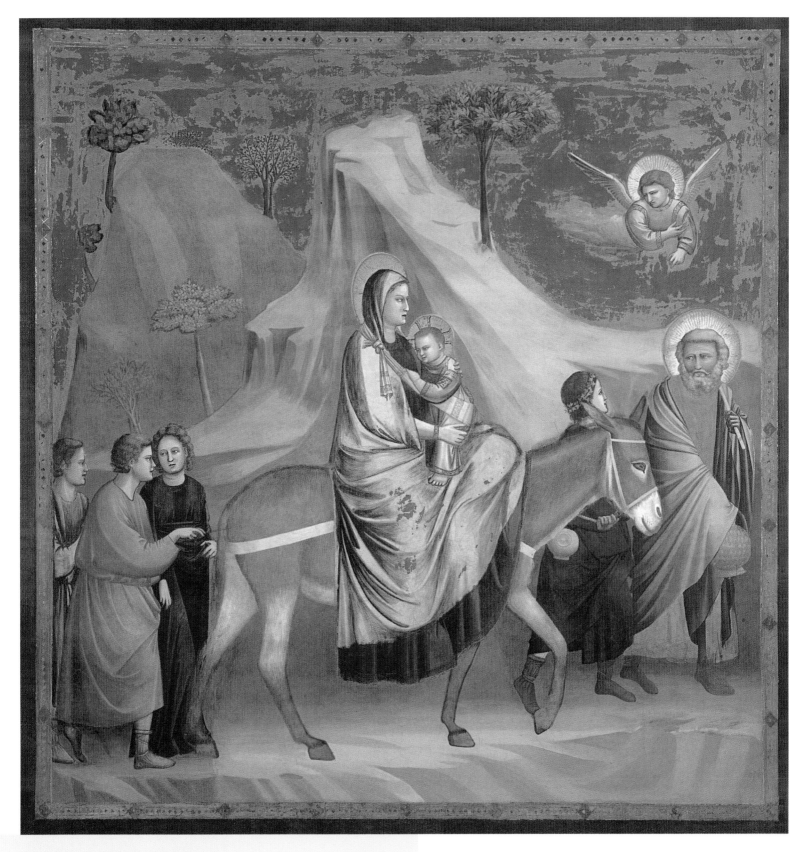

The Flight into Egypt

This fresco in the Arena Chapel captures the worry of Jesus's family as they leave Bethlehem to escape King Herod's demand that all newborn babies be killed. Look how tightly Mary holds on to the baby Jesus, and how wrinkled the grey-haired Joseph's brow is. Even the angel flying above hurries them on. Only the donkey seems unworried, slowly plodding along.

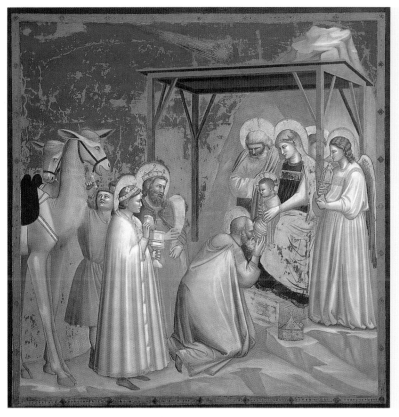

The Adoration of the Magi (and detail)

This fresco in the Arena Chapel shows the three kings giving gifts to Jesus. Giotto has used the appearance of Halley's Comet in 1301 as the basis for his Star of Bethlehem. This is the first recognizable drawing of the comet in history, and is the reason the European Space Agency's mission to Halley's Comet in 1985 was called 'Giotto'.

Christ Giving His Blessing

Giotto has painted Jesus, looking very serious, with one hand raised in blessing. This fresco is painted on the ceiling, hence the starry sky.

Want to see more?

www.abcgallery.com/G/giotto/giotto.html

Giotto trained as an artist in the workshop of the successful painter Cimabue in Florence. Cimabue had started to paint more lifelike figures after looking at classical art in Rome, but Giotto went even further. He painted solid, realistic bodies expressing real emotions, like the figures in the **Adoration of the Magi** on the Arena Chapel wall.

High up on the chapel ceiling Giotto and his assistants have also painted pictures of **Christ** and Mary, and other Biblical figures. These paintings are richly decorated.

One of Giotto's most famous paintings of Christ is in the church of Santa Maria Novella in Florence. When he was in his early twenties, Giotto painted some of his first works for this church, including a **Crucifix** on a wooden panel shaped like a cross. Blood drips from Jesus's hands and feet, and spurts out of the wound in his chest. Against the patterned and blue background the body looks as if it really is nailed up there. The work is over 5 metres (16 feet) tall and hangs above the heads of worshippers. It is a powerful piece of art, and Giotto is rightly proud of it.

Four years ago, in 1301, he bought a house in the parish of Santa Maria Novella. Now he thinks of his family and wonders when he will see them again. He walks out of the chapel into the spring sunshine.

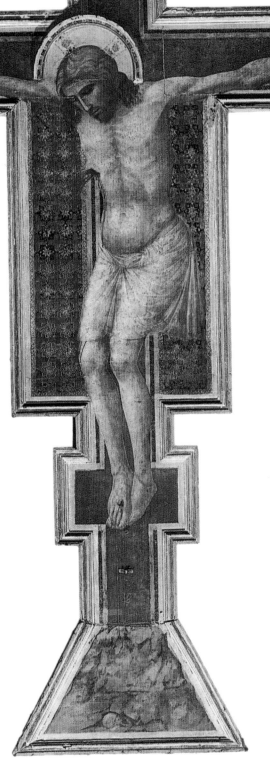

Crucifix

Unlike other artists of the day, Giotto wanted to look at real things, to study nature, and paint what he saw. He wanted his painting of Jesus to seem like a real body on a cross. Jesus's stomach is swollen, his fingers curl outwards and his legs bend awkwardly. Up to this time most artworks were made in mosaic – using tiny squares of coloured glass and stone – and it was impossible to make figures seem lifelike.

Did you know?

* Cimabue is said to have spotted Giotto's artistic talent when Giotto was only 10 years old.

* Giotto's best friend was Dante, Italy's most famous poet, who wrote 'The Divine Comedy'.

Leonardo da Vinci

Leonardo da Vinci (1452–1519) was a scientist, architect, town planner and philosopher as well as a painter and sculptor. He created some of the most amazing paintings and drawings of his time, including the world-famous *Mona Lisa*.

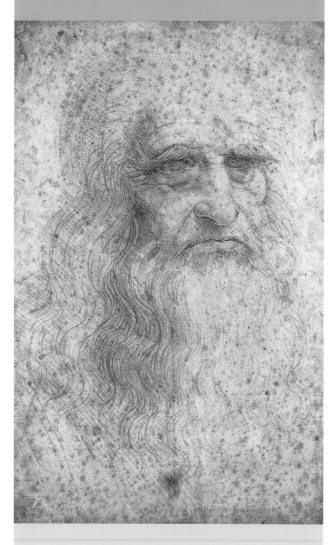

Self-portrait, 1512–15

1506

Leonardo da Vinci stops painting and steps away from the easel. The woman who is sitting in front of him smoothes down the veil that covers her hair. She wants to know how much longer she will have to sit like this, her body turned away from the painter but her eyes meeting his gaze. Leonardo smiles and tells her they are nearly finished. He is very pleased with the landscape he has painted behind her. It looks strange and mysterious because the two sides of the landscape don't seem to match up.

Leonardo has always enjoyed experimenting. Recently he has been thinking about redesigning a **machine** he has been working on for years – a machine to help people fly. He studied birds and insects, trying to work out how they achieve flight. In fact, he has studied most things. He is curious about every aspect of the world, and has designed many machines, buildings and weapons. He even cuts up **bodies** and draws what he finds inside. He is left-handed, and writes in his notebooks in 'mirror writing', back-to-front, so no one else can read his notes.

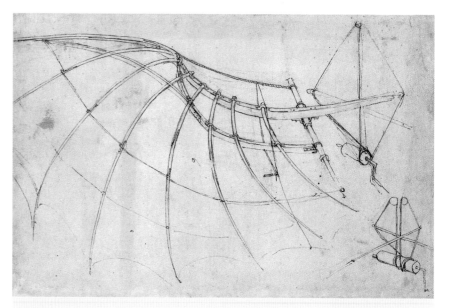

Flying machine drawing

For over twenty years Leonardo tried to design a flying machine. Some of his designs have rotary devices like helicopters; others show a man strapped in as if in a hang glider, with giant wings beating overhead. Leonardo never stopped studying nature to try and work out how to achieve flight.

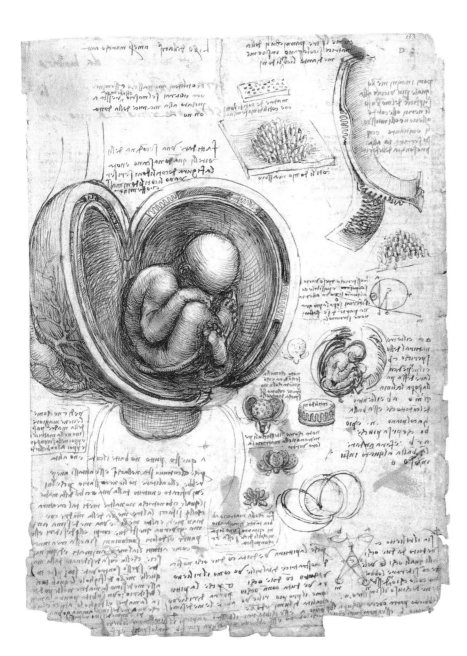

Leonardo was passionate about studying human anatomy. He claimed to have cut up over thirty bodies of men and women of all ages. In his many notebooks are studies of babies in wombs, the central nervous system, the human skeleton and the position of all internal organs.

Did you know?

* Leonardo was a vegetarian.

* He once designed an 8-metre-high (25-foot) rearing horse to be made in bronze for the Duke of Milan, but the bronze was used to make cannons instead.

* He trained in Florence with his father's friend, a famous painter called Andrea del Verocchio.

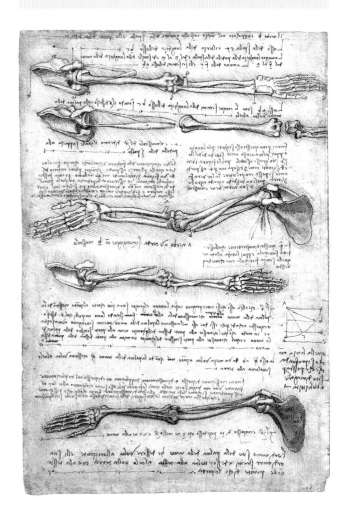

The portrait he is working on now is being made with oil paint. Leonardo likes trying new things and oil paint is quite new in Florence. Up until recently all artists used tempera, where different coloured powders called 'pigments' were mixed with egg yolk to form paint. Tempera dried quickly, but oil paint took days to dry. The fact that it was slow-drying allowed Leonardo to smudge colours together so no one could see where one ended and another began. He liked the new paint so much that he tried to use it for a big wall-painting commissioned by the government of Florence. It was a scene of the battle of Anghiari, and he had started painting it on the wall of the council chamber. By his calculations he should have been able to use the special oil paints he had mixed, but for some reason the paint refused to dry and

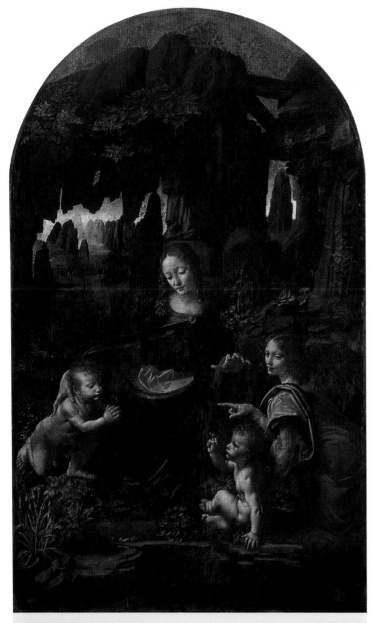

The Virgin of the Rocks

Leonardo rarely finished his paintings, and there are only a few completed works that experts agree are by him. He was asked to paint this picture for San Francesco Grande church in Milan, Italy. He was given a seven-month deadline to complete it – he delivered the final painting twenty-five years later.

want to see more?

www.artcyclopedia.com/artists/leonardo_da_vinci.html

www.ibiblio.org/wm/paint/auth/vinci

www.leonardo.net

slid down the wall onto the floor. He had given up – the experiment had failed – but the government were now hounding him, asking him to repair the painting or give them their money back.

Unfortunately for the government, Leonardo is a very slow worker. He took twenty-five years to complete his painting **The Virgin of the Rocks**. He was a little faster on another work – a painting called **The Last Supper** on the wall of the dining room in the Santa Maria delle Grazie monastery in Milan. This work took Leonardo four years to paint. It shows a long table with Jesus and his followers all sitting down to eat. Leonardo didn't use the traditional technique of fresco; he used tempera instead. Recently he had heard reports that the paint was starting to peel off.

Leonardo sighs and looks at the woman sitting in front of him. She is the wife of Francesco del Giocondo, a rich merchant who lives in Florence. Francesco asked Leonardo to paint his wife's portrait three years ago, but it still isn't finished. Although Leonardo enjoys painting, the truth is that he enjoys thinking about how the painting might work, rather than actually completing it. This means he rarely finishes anything. When Francesco asked Leonardo to paint his wife, Leonardo didn't actually have any other work lined up because of his reputation for giving up on projects.

The woman's name is Lisa Gherardini, but she will be known throughout history as **Mona Lisa**. Leonardo dabs his brush into the oil paint mixed on his palette. He now starts to rework Lisa's mouth, drawing the corners up slightly into a little smile. He has employed jesters and a musician to entertain her today, but he can see that she is tired. He tells her they can stop soon.

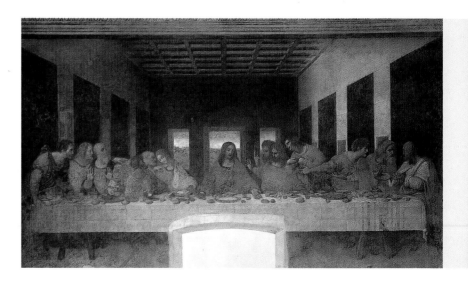

Mona Lisa

This painting is one of only four female portraits by Leonardo to survive. Its name is taken from 'Monna Lisa', an abbreviation of *mia donna Lisa*, or 'my lady Lisa'. Perhaps the most famous painting in the world, it is now seen by five and a half million people each year in the Louvre museum, Paris, where it is housed behind bulletproof glass.

WHY DON'T YOU?

* Draw a fantastic landscape.

* Imagine the most beautiful place in the world, or the scenery on Mars, or somewhere you once dreamed about....

* You can invent strange trees and flowers, mysterious mountains, winding paths, big lakes, and much more.

The Last Supper

This recently restored wall-painting represents a moment in time when Jesus told his disciples that one of them would betray him. Look at their faces: Leonardo wanted to show what people were thinking, not just how they looked. You can see from the variety of expressions that he was very good at it.

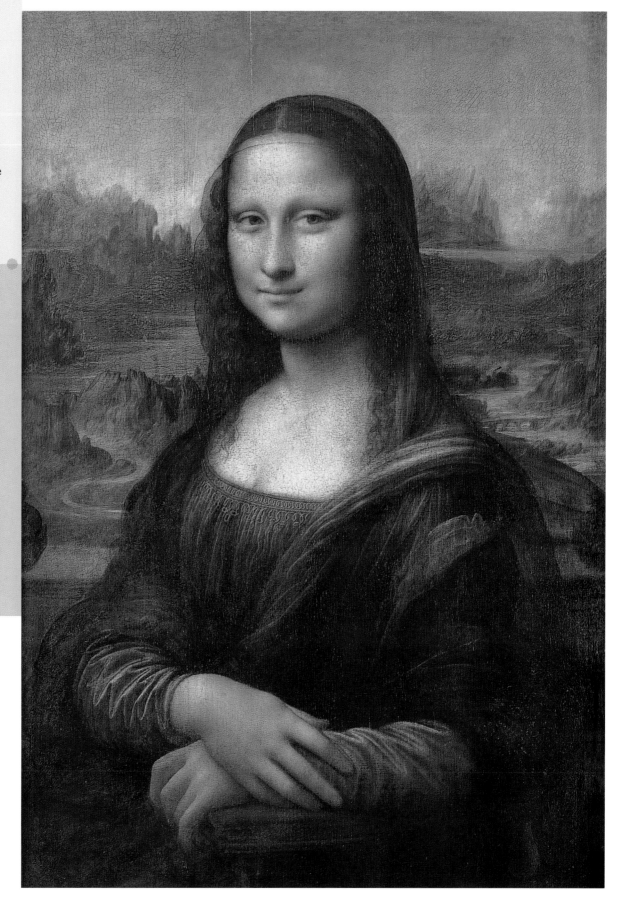

ALBRECHT DÜRER

Albrecht Dürer (1471–1528) remains Germany's most important artist. He was not only a talented painter but also a master printmaker, who created engravings and woodcuts of incredible skill and beauty.

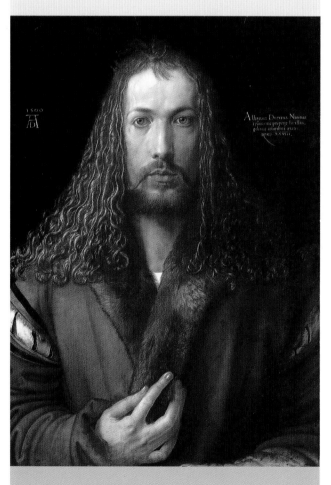

Self-Portrait at 29, 1500

1515

Albrecht Dürer stands in his print room on the second floor of his house in Nuremberg, Germany. He is 44 years old. In front of him assistants prepare a big wooden printing press, turning wheels and mixing ink. He can hear a pupil cleaning paintbrushes in the room next door. Dürer likes being asked to paint important paintings, but it is through printmaking that he has been able to afford the impressive house in which he now stands.

Dürer is the son of a goldsmith and spent three years learning how to work with gold, but really he wanted to be an artist. He learned to paint, but he made his name producing prints. The good thing about printmaking, Dürer thinks, is that – unlike painting pictures – you can make lots of prints very easily. This means more people can get to know your work and buy it.

Engravings such as Dürer's **Adam and Eve** have been very successful. He made the figures seem lifelike and three-dimensional by using short lines for shading, as they did in Italy. No one had done this before in Germany, and Dürer soon became Germany's most important artist.

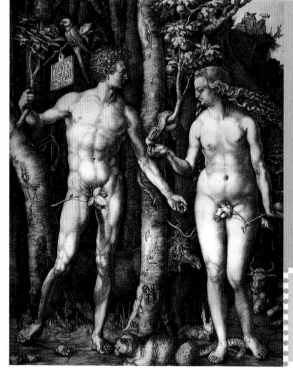

Adam and Eve

This engraving shows Adam and Eve standing by the Tree of Knowledge in the Garden of Eden. Dürer used classical statues as models for the figures, but drew many of the animals from life. That's why the creatures look so realistic. There's a cat and mouse, a parrot, a snake.... See how many animals you can spot.

Did you know? Dürer had seventeen brothers and sisters.

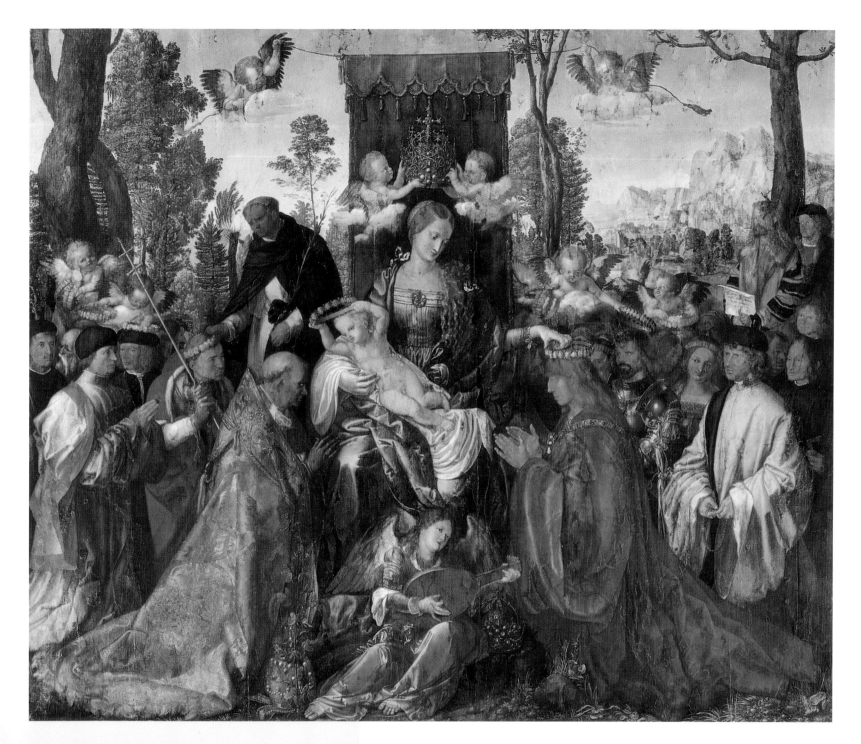

The Feast of the Rose Garlands

This painting is full of important people. The Pope kneels to the left of baby Jesus; the Emperor of Germany kneels to the right. Other rich merchants crowd in, keen to be included in the painting. Look under the tree on the right-hand side, and you will see a man looking back at you. This is Albrecht Dürer, who was so proud of his painting that he included this portrait of himself in it. The piece of paper he holds includes his signature, the date and a statement that the painting took him five months to paint.

Now Dürer walks over to a chest and takes out some drawings on blue paper. He found them the other day, beneath some old prints. He made them in preparation for a big painting called **The Feast of the Rose Garlands**. This altarpiece was made for the German merchants' church in Venice in 1506. It shows Jesus as a baby on his mother Mary's knee, handing out headdresses made of roses. A religious ceremony is being acted out, called the Rite of the Rosary, in which everyone receives a rose garland to emphasize that the church loves everybody, rich or poor. Dürer was very pleased with the finished painting.

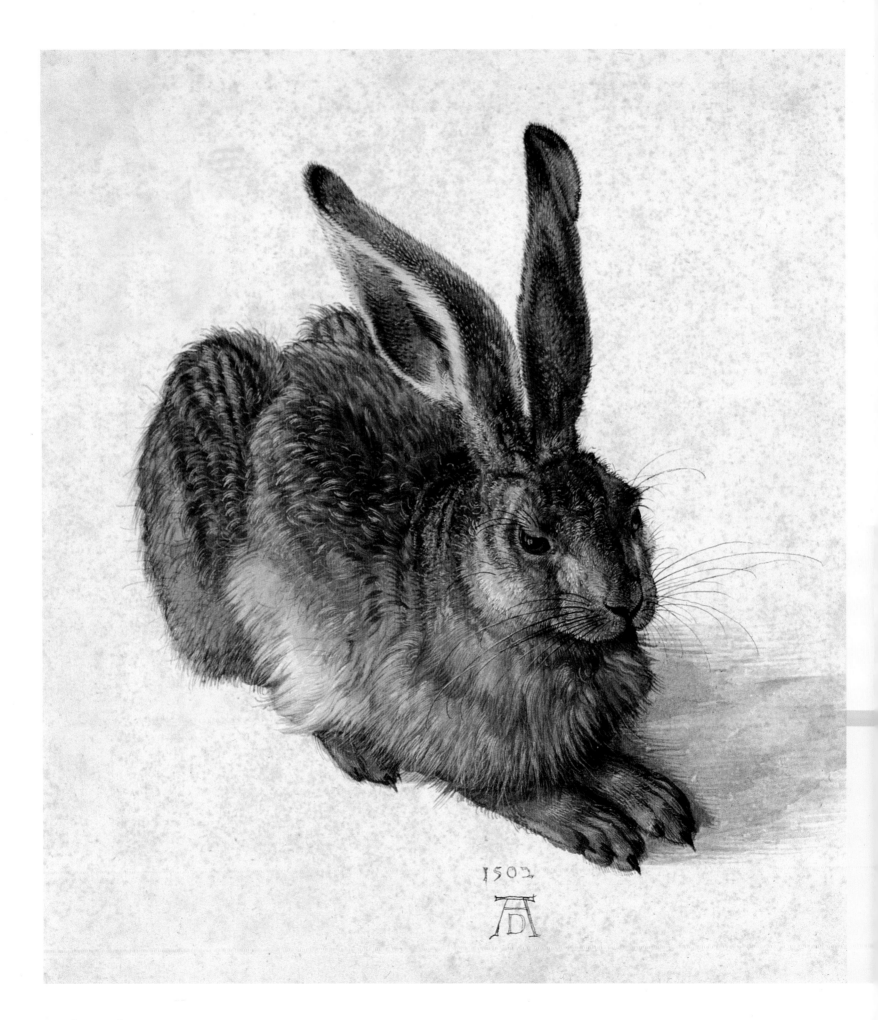

1502

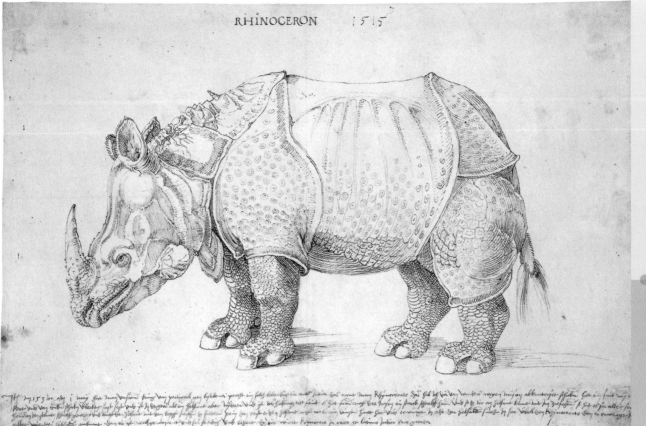

RHINOCERON 1515

The Rhinoceros

Dürer included a description of the rhino on his print, saying the animal was armour-plated, covered in scales and the colour of a speckled tortoise. We now know this isn't true, but Dürer hadn't actually seen a rhino when he made this print. Nonetheless, before photography was invented, it was the trusted picture of a rhino for centuries across Europe.

Want to see more?

www.artcyclopedia.com/ artists/durer_albrecht.html

www.ibiblio.org/wm/paint/ auth/durer

Hare

Dürer was fascinated by the natural world and drew it all the time. (Look how detailed the grass at the bottom of *The Feast of the Rose Garlands* is.) This watercolour is a detailed likeness of a hare. Dürer's signature 'AD' is beneath the hare, with the date, 1502.

WHY DON'T YOU?

* Make a potato print of an animal.
* A rabbit? A cat? Something more exotic?
* Take half a potato. Draw the animal shape on the flat surface. Cut around the shape so that it is raised. Press the potato gently into a flat dish of paint. Stamp the animal shape onto a sheet of paper.

Beneath his workshop, rolled up in the hall, are bundles of prints which his wife will take to the next market fair to sell. Today he is going to print a woodcut of a **rhinoceros**. His drawing of a rhinoceros has been copied onto a piece of wood. Then it was carved around so that the image was raised. Now assistants are covering the surface of the wood with ink. Next they will press a sheet of paper over the wood so that the inky image prints onto the paper.

The assistants call out to Dürer that they are ready, and he puts his drawings down. The assistants turn the wheel of the press and the paper with the image of the rhinoceros on it slowly comes out. They will print some more today, and more still tomorrow.

This print is of an Indian rhinoceros. The animal was sent to the King of Portugal earlier in the year. Dürer hasn't seen the creature – in fact it is the first rhinoceros in Europe for over one thousand years – but he has read about it. He thinks the interest in this strange beast should make the print sell well. He doesn't know it yet, but although he has done many fine illustrations of animals – including a lifelike **hare** – this print will turn out to be the most influential animal print ever made.

MICHELANGELO

Michelangelo di Ludovico Buonarroti Simoni, now known as Michelangelo (1475–1564), was a sculptor, painter, architect, war adviser and poet. He was known as 'the divine one' during his lifetime, and was one of the most brilliant men of his day.

MICHELAGINO BVONAR. PIT.
SCVLTORE ET ARCHITET.

Woodcut from Giorgio Vasari's
Lives of the Artists, **1568, by Cristoforo Coriolano**

1512

It is a sunny October day but Michelangelo is standing inside the **Sistine Chapel** in the Vatican, the Pope's palace, in Rome, Italy. He is watching workmen take down the final pieces of a wooden scaffold. He designed this scaffolding himself, and for the last four years he has been perched on it, working by lamplight, painting giant figures all over the ceiling. These figures tell stories from the Bible. To start with, Michelangelo had lots of assistants to help him, but he is a perfectionist and in the end he sent them away and finished the ceiling alone.

Michelangelo was well paid for the Sistine Chapel – over £300,000 ($600,000) in today's money – but he had to work hard for it. To make the painting stick to the ceiling he had to use the difficult technique of 'fresco'. At first he didn't get it right and the whole thing went mouldy. He had to paint it bit by bit, tracing each figure from special drawings he made called 'cartoons'.

Now, though, Michelangelo raises his head and looks up. The ceiling of the chapel is finished. He turns around as someone rushes through the door. It is the Pope, impatient to see the new painting. Thankfully he loves it and Michelangelo is allowed to go home. He walks back to his house, pleased the whole thing is over.

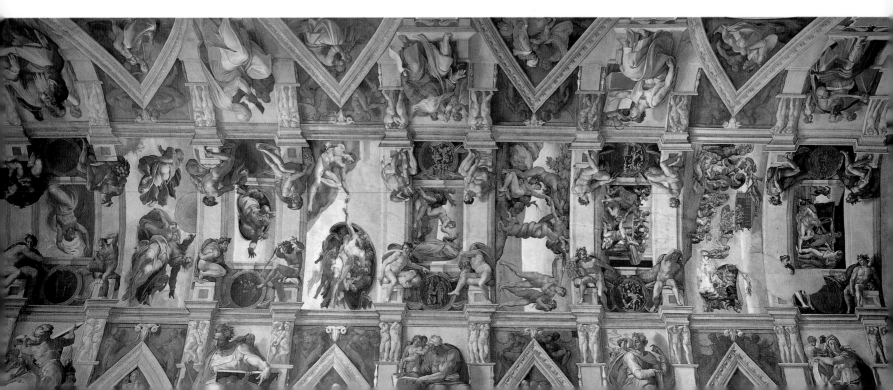

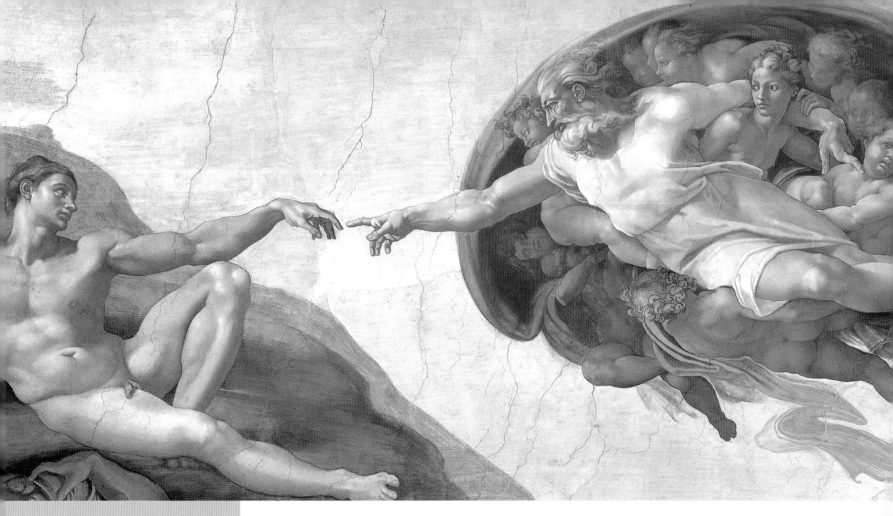

The Creation of Adam (detail)

This is the best-known detail from the Sistine Chapel ceiling. In it, the fleshy hand of God – a grey-bearded man – is about to touch the limp bony hand of Adam to give him life. Can you find this detail in the picture of the whole ceiling on the opposite page?

The Sistine Chapel

The Sistine Chapel ceiling is half the size of a soccer pitch. Nine scenes from the Bible – from God creating Adam, to Noah and the Flood – stretch along its length. Lots of prophets and sibyls (female prophets who can see the future) sit underneath.

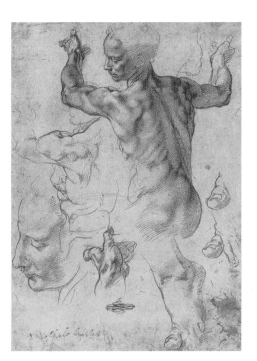

Want to see more?

www.michelangelo.com/buonarroti.html

www.ibiblio.org/wm/paint/auth/michelangelo

WHY DON'T YOU?
Draw a scene from your favourite book.

The Libyan Sibyl (sketch and detail)

You can tell Michelangelo is a sculptor in his heart. All the figures he painted on the Sistine Chapel are very solid. Look at the muscles on the back and arms of this female prophet. It looks as if she is made of flesh and blood, not paint.

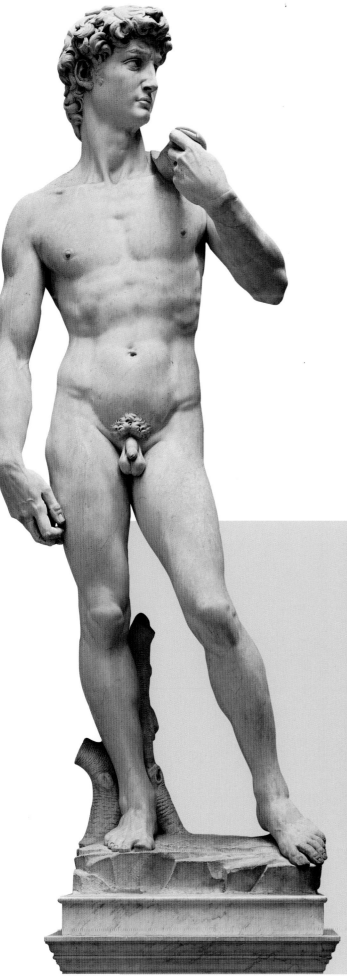

Michelangelo really prefers to carve sculptures than to paint. A few years before working on the Sistine Chapel, he sculpted **David**, from the Bible story of David and Goliath. The sculpture is massive, the biggest made for 1,500 years, since Roman times. But when the Pope asked Michelangelo to paint the chapel ceiling, he had to stop making sculptures for a while.

Today he sits, aged 37, at home in Rome, exhausted. He can hardly see after working in such bad light in the chapel, but he manages to write a letter to his father, telling him the Pope is happy with the ceiling. Then he goes upstairs to bed. He wears tight boots to stop himself getting cramp, and he often falls asleep fully clothed. When he tries to take his boots off, they have been on for so long that part of his skin comes off with each boot....

Perhaps his feet are the reason he doesn't sleep. Long after midnight you can see a faint light through the window of his studio at home. He is standing in front of a block of marble, hammer in one hand and chisel in the other, a candle attached to his hat so he can work at night. He lifts the hammer and smashes it onto the chisel. A tiny piece of marble falls to the floor. A new sculpture is underway.

David

Michelangelo carved this 4-metre-high (13-foot) figure of David in just a couple of years. He built scaffolding around the block, and wouldn't let anyone see what he was doing. No one believed a sculpture could be made from this piece of marble because it was too tall and thin, but Michelangelo managed it. When a senior politician saw David, as Michelangelo was finishing the statue off, he commented that the nose was too big. Michelangelo climbed up the scaffolding and pretended to chisel away at the nose until the politician was happy. In fact all he did was sprinkle marble dust from his hand — the nose never changed.

Did you know?

* Michelangelo used real people as models for his figures.

* His own nose was almost entirely flat. When he was a teenager in Florence, it was broken by another trainee artist who was jealous of his talent.

The Last Judgment (detail)

Twenty-five years after finishing the Sistine Chapel ceiling, Michelangelo was back with a paintbrush in his hand, painting the back wall behind the altar. His subject was 'The Last Judgment' from the Bible, where souls rise to heaven or are sent to hell. Look for the skin hanging in one man's hand near the middle — Michelangelo has painted his own face onto it.

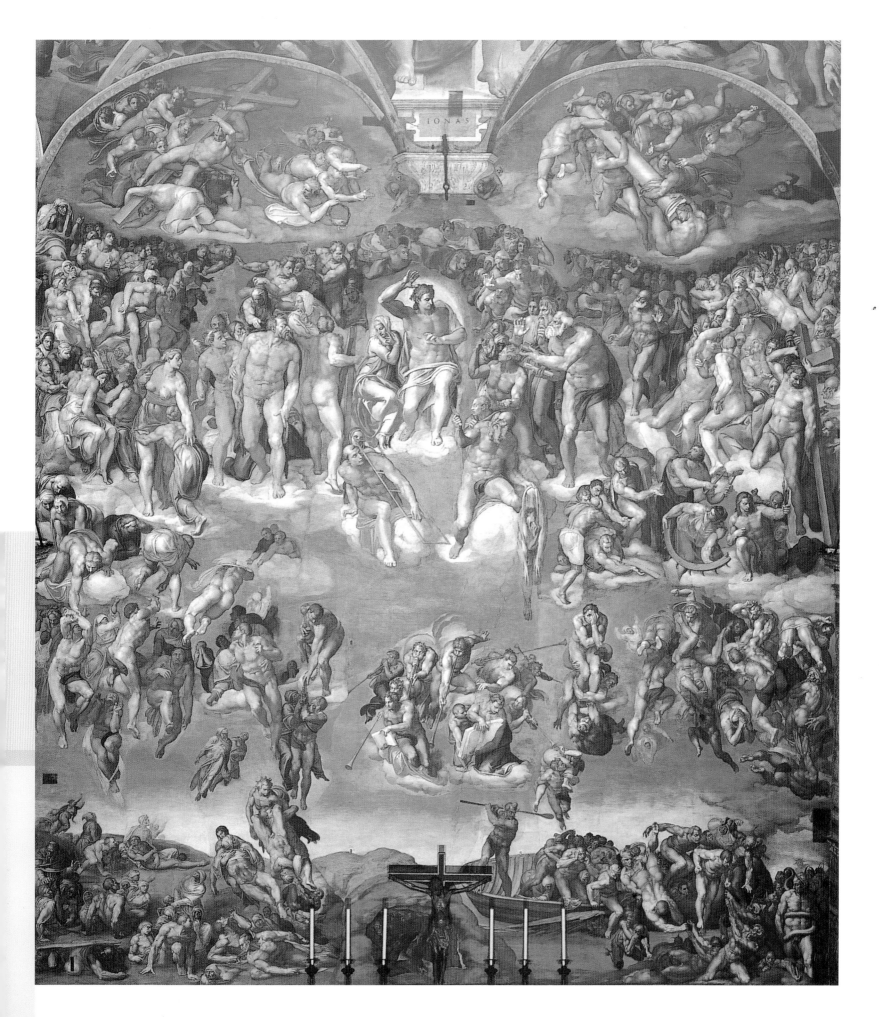

RAPHAEL

Raffaelo Sanzio, now known as Raphael (1483–1520), was thought to be the greatest painter of his time. He moved from Florence to Rome to work for the Pope, and painted a wide range of religious paintings, portraits and frescoes.

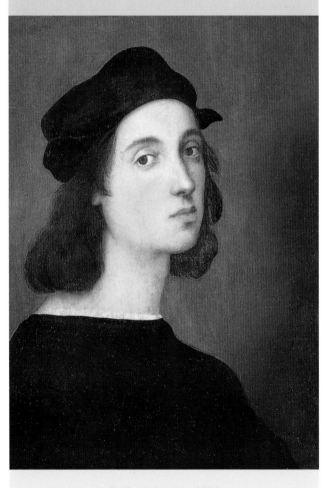

Self-portrait, c. 1506

1513

Raphael stands in front of a blank wall in Pope Julius II's apartment in the Vatican, Rome, Italy. The Pope died a week ago, but Raphael has been advised to continue with the frescoes he is working on. He is waiting for his assistants to cover part of one wall in wet plaster so he can start painting.

Raphael moved to Rome five years ago when he was asked to decorate the Pope's apartment. He had been living in Florence painting religious pictures such as **The Ansidei Madonna** for a church in Perugia. It shows the influence of the successful artist Pietro Perugino, in whose workshop Raphael had learned his art.

Raphael had moved to Florence from Perugia when he was 21 years old. He was inspired by seeing Leonardo da Vinci and his drawings for the *Mona Lisa* (see page 15), and also by seeing Michelangelo's new sculpture of *David* (see page 22). After half of Michelangelo's Sistine Chapel ceiling was unveiled in 1511 (see page 20), Raphael decided to add his hero's portrait to the fresco he was working on in the first room of the Pope's apartment. The fresco was called **The School of Athens**.

The Ansidei Madonna (The Madonna and Child Enthroned with St John the Baptist and St Nicholas of Bari)

This is an early altarpiece by Raphael, and is painted with great attention to detail. Look at the embroidery on the clothes, and the precise landscape through the arched window. No one looks at each other, and the painting seems very still, but all the heads tilt to the right, helping your eye pass from one figure to the other.

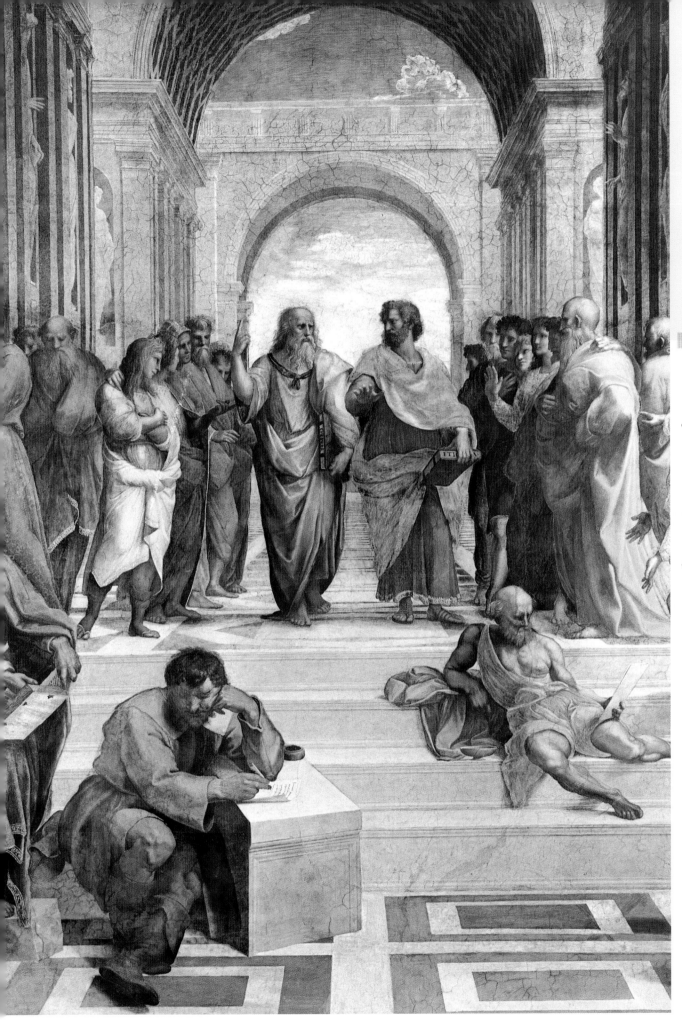

The School of Athens (detail)

The figures represent the greatest minds of classical times – Plato, Aristotle, Pythagoras, Socrates, Euclid. They are in fact portraits of people Raphael knew (including himself). Michelangelo is posed as Heraclitus, sitting on his own, leaning on a block of marble and looking at the floor.

WHY DON'T YOU?

* Start a scrapbook. Cut out pictures of famous artists, or great writers, or brilliant musicians, and paste them in your book.

* You could also write down interesting information about them.

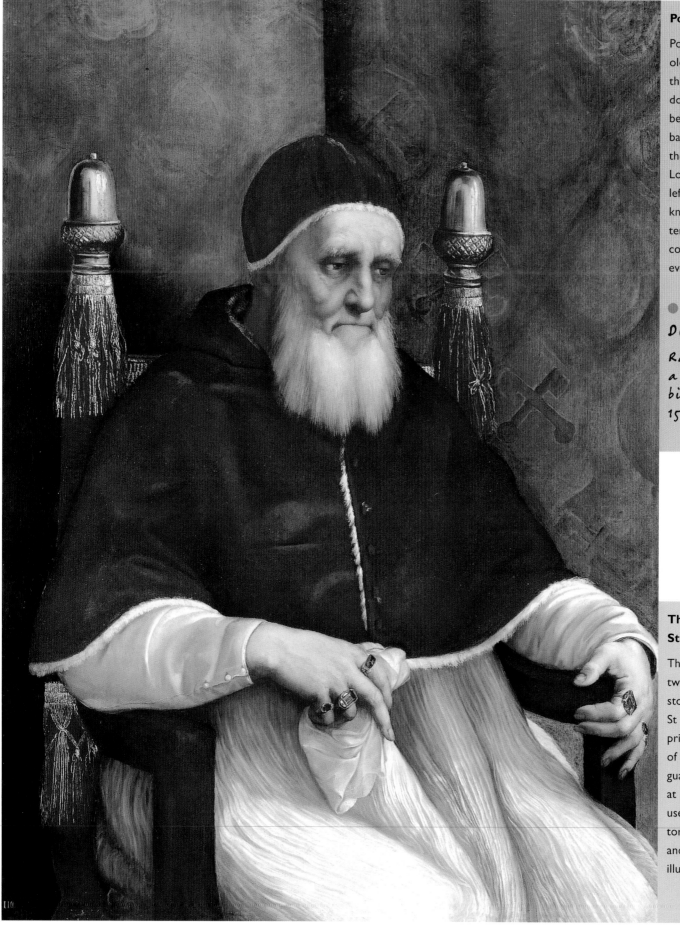

Pope Julius II was 70 years old when Raphael painted this portrait. His eyes look down, and he has grown a beard to acknowledge a big battle he lost in Bologna. But there is still fight left in him. Look how tightly he grips the left arm of his chair. He was known for his fearsome temper, and this portrait continued to frighten people even after his death.

● ● ● ● ● ● ● ● ● ●

Did you know?
Raphael died of a fever on his 37th birthday, in April 1520.

The Deliverance of St Peter from Prison

This wall painting shows two parts of the same story: the angel helping St Peter escape from his prison cell, and the pair of them passing sleeping guards. The scenes are set at night, so Raphael cleverly uses light from the guard's torch, the crescent moon and the angel's aura to illuminate the painting.

This fresco is in the Pope's study. It shows lots of men talking, writing and discussing philosophy in a classical temple dedicated to learning, like a school. By the time Raphael finished it, he was established as the greatest painter in Rome. People praised him for his ability to paint all types of people and to give them all unique expressions. Some look excited and curious; others are thinking and are silent.

Raphael slipped effortlessly into court life in the Vatican when he arrived in 1508. He was a polite and gracious man who was at ease talking to anybody, and people admired his work such as **The Triumph of Galatea**.

By the time he finished painting **the Pope's portrait** in 1512, the Pope was ill and looked like a frail old man. Now, a year later, he has died. Raphael's portrait has gone on display in the church of Santa Maria del Popolo, and lots of people have been lining up to see it. They still find the Pope intimidating because the painting is so realistic.

Back in the Pope's apartment, Raphael's assistants are still mixing the plaster to prepare the wall for their master's new painting. It will be called **The Deliverance of St Peter from Prison**. Raphael has made lots of sketches of St Peter, along with the angel who rescues him, and the guards on duty. He has also completed a full-size drawing of the wall – a 'cartoon' – and will use this to transfer his design onto the wet plaster. This painting is going to be a daring night scene, and it will arch right over the window.

The Triumph of Galatea

This fresco was painted for the garden room of Agostino Chigi's villa on the outskirts of Rome. It shows the Greek sea nymph Galatea surrounded by mermen, dolphins and cherubs. Everything seems to be moving in the painting, circling and dancing round Galatea.

Want to see more?

www.artcyclopedia.com/artists/raphael.html

www.ibiblio.org/wm/paint/auth/raphael

www.abcgallery.com/R/raphael/raphael.html

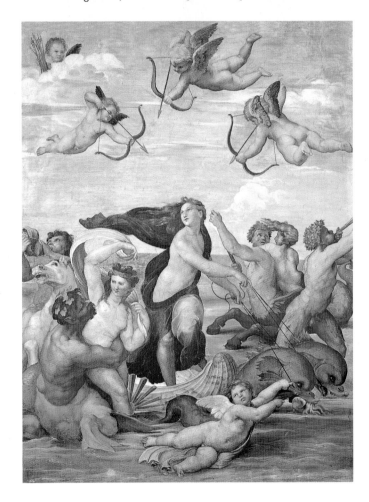

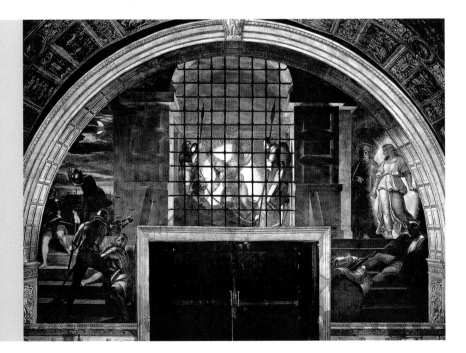

TITIAN

Tiziano Vecellio, now known as Titian (c. 1490–1576), was for sixty years Venice's most important painter. He painted altarpieces and other religious works, but was most famous for his lifelike portraits of emperors, popes and the nobility.

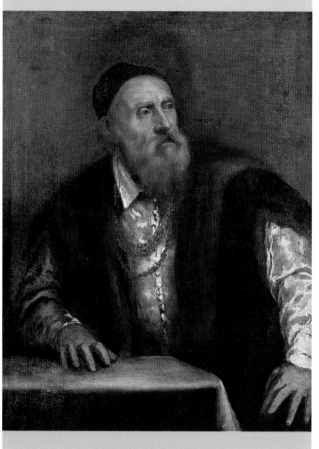

Self-portrait, c. 1550–62

1548

It is a crisp autumn day as Titian walks through his rooms in the Fugger Palace in Augsburg, Germany. He is getting ready to make the long journey home to Venice, Italy. He checks that his painting equipment is securely packaged.

Back in Venice, Titian has a big house and studio overlooking the island of Murano and the sparkling blue lagoon. But he left it behind nine months ago to come and work in Augsburg for Charles V, Emperor of the Holy Roman Empire. Titian has painted many portraits this year, including **Charles V on horseback**, which he finished recently. This life-size work is currently propped up in the palace garden to allow the protective coat of varnish that covers the paint to dry.

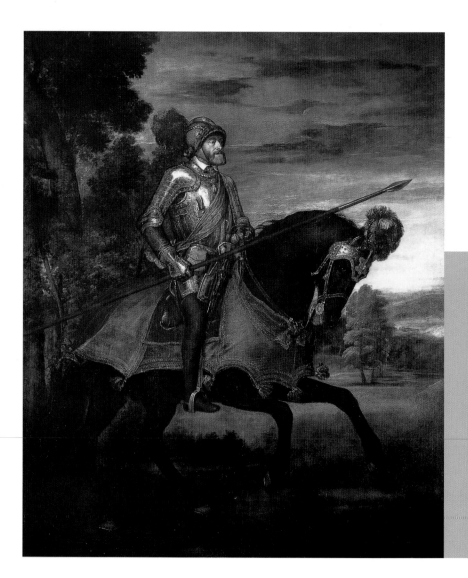

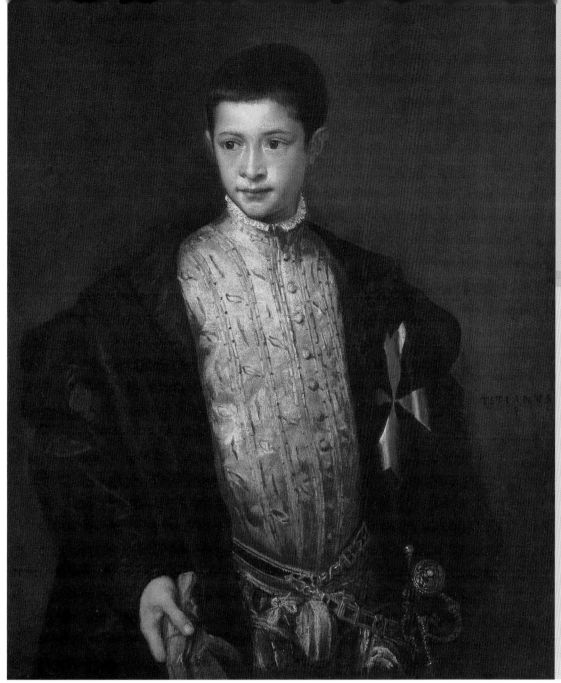

Ranuccio Farnese

The 12-year-old Ranuccio
Farnese travelled to Venice in
1542, when Titian painted this.
The portrait was praised for
being very lifelike, despite
Titian only meeting the boy
a few times. He seems shy
and a little uncomfortable
in his adult clothes.

Did you know?

* Titian left home and moved to Venice when he was 10 years old.

* He studied with Gentile Bellini and Gentile's brother Giovanni, who was Venice's most important painter.

* When Giovanni Bellini died in 1516, Titian became Venice's official painter, as well as Emperor Charles V's exclusive portrait artist.

Charles V on Horseback

This painting celebrates
Charles V's victory in the
battle of Mühlberg. It copies
the pose of a classical statue
of a Roman emperor, Marcus
Aurelius, and is very flattering
to Charles V, who wasn't very
handsome. Titian used lots of
expensive pigment called 'red
lake' to make the horse, rider
and sunset seem to glow and
look splendid.

Titian travelled to Augsburg with six of his assistants, but many more are still at work in his studio in Venice, which is run by his son Orazio. A painting by Titian is much sought-after, and consequently his assistants do much of the work. After Titian sketches out the painting he turns the canvas to the wall and sometimes doesn't look at it again for months. His assistants work on the figures until it is time for Titian to add the finishing touches. He often does this with his fingers, and his nails frequently have oil paint under them.

Unlike other artists, Titian doesn't design buildings or make sculptures as well. He concentrates on painting, and is known and admired as a portrait painter. A few years earlier, back in Italy, he painted **Ranuccio Farnese**, Pope Paul III's grandson. He has also painted Charles V and his family many times.

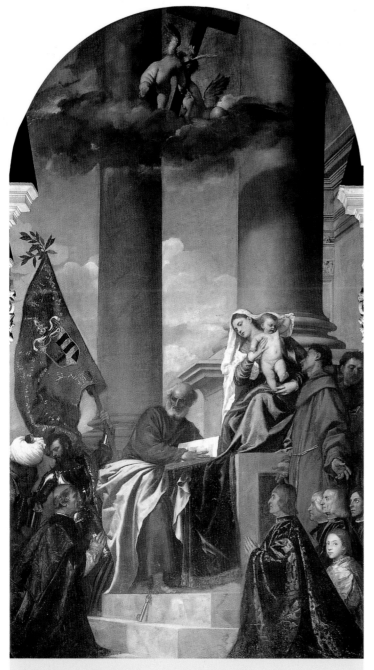

The Pesaro Altarpiece

This altarpiece was paid for by Jacopo Pesaro, a nobleman from Venice. It shows Jacopo and his family kneeling in prayer, with the Virgin Mary and Jesus behind them. Titian directs the eyes of St Peter (sitting in the blue and yellow robe) and the Virgin towards Jacopo, on the left. The baby Jesus looks down at Jacopo's family on the right.

Want to see more?

www.artcyclopedia.com/artists/titian.html

www.abcgallery.com/T/titian.titian.html

Suddenly one of Titian's assistants bursts into the room and asks the painter to follow him to the garden. The painting of Charles V on horseback is lying on the ground, a stake poking through the horse on the canvas. The painting has blown over in the wind. Titian looks at the damaged work and thinks the tear can be repaired, but there isn't time for him to do it before he leaves. So he sends his assistant to call on the painter Christoph Amberger, whom he hopes will agree to mend it for him.

Titian thinks back to the first time he met Charles V. He painted his portrait in 1529 but the Emperor didn't like it, refusing to pay the full price. He thought Titian's style wasn't detailed enough, that you could see the brushstrokes. However, the Emperor soon came to see that this is what made Titian's portraits special – the finishing touches were applied quickly to capture the spirit of each person he painted. It made his portraits seem real and alive.

Titian has also made church paintings, such as the **Pesaro Altarpiece**, and mythological scenes, such as **Bacchus and Ariadne**. He painted these works in Italy. He wishes he was there now, though he dislikes travelling. He had to cross the Alps last winter to get to Augsburg, and only did it because the Emperor provides him with lots of work and pays him plenty of money. Now he is keen to be home in Venice.

He sighs and walks back indoors. He has already spent a lot longer on the painting of the man on horseback than he planned, changing the Emperor's body and head so he now looks into the distance. He wanted to make the Emperor seem thoughtful. They have spent a lot of time together over the last nine months, and have become friends. The Emperor made sure Titian's rooms were near his own, so he could visit him any time he wanted to.

Now there is a knock on the door. Christoph Amberger enters and agrees to repair the damaged painting. Titian thanks him, and starts to think once more of home.

El Greco

Domenikos Theotokopoulos (1541–1614) was known during his lifetime and since as El Greco. He spent most of his working life in Spain, painting altarpieces and religious works. His style reflected artistic trends in Italy, but in Spain it was seen as unique, and for most of his life he was much in demand.

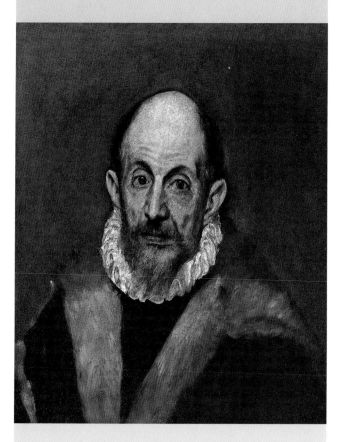

Self portrait, 1584–1604

1613

El Greco is sitting at home in his apartment in the Villena Palace in Toledo, Spain. He is waiting for a possible patron to come and see examples of his work. El Greco is old and sick, but still painting when he can. He has a miniature collection of copies of his best works, tiny paintings on canvas that he shows buyers to help them choose the subject they want. His son Jorge Manuel, whom he painted as a boy in **The Burial of Count Orgaz**, works with him now, helping him in the studio.

Few people ask El Greco to paint grand altarpieces or portraits anymore, but that was how he first made his name in Spain. His altarpiece **The Assumption of the Virgin**, which he painted for the church of Santo Domingo el Antiguo in Toledo, was a big success.

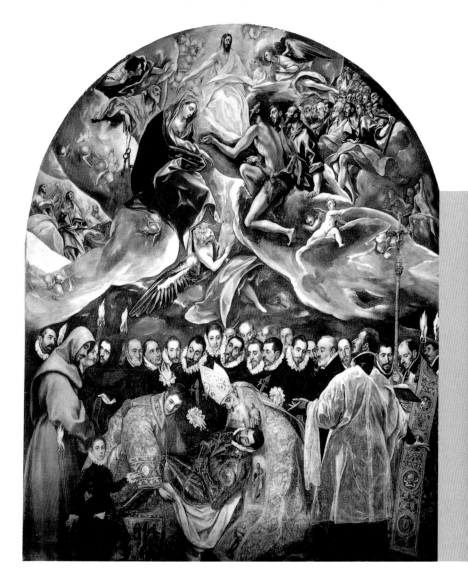

him to Archbishop Warham in London. Holbein painted Warham, More and their friends while he was in England for the first time. He also sketched **Mary Wotton, Lady Guildford**. But he really had his sights set on painting the King of England, Henry VIII.

When Holbein returned to England for the second time, in 1532, he found his old friends either dead or out of favour. Times had changed in England – Henry VIII was establishing his own church, the Church of England, and had appointed himself head of it. Not everyone thought he should be able to do this. Sir Thomas More, for one, challenged him and resigned as the King's Lord Chancellor. Holbein realized that to continue his success as a painter in England he needed royal support. So he decided his painting *The Ambassadors* had to be so brilliant that it would attract the King's attention and get him a regular royal income. He would be successful. In 1536 he began painting **King Henry VIII**.

But this is in the future. For now it is still 1533 and the ambassadors have just arrived in Holbein's studio. They each lean one arm on the table. Holbein realizes it is a good thing this is the last time they are posing for him – the heavy fur-lined coats they have chosen to wear in the painting are already too hot for the spring day. Georges de Selve places an open hymnbook on the bottom shelf of the table, in front of the lute, as Holbein steps towards the life-size painting and picks up his brush.

He is concentrating on the dagger that Jean de Dinteville holds in his right hand. It is hidden away in an ornate gold case. Holbein has designed cases like that. In fact, he has designed everything from book illustrations and fountains to gold cups and pieces of jewelry. He looks at the way the dagger-case catches the light in contrast to the soft fur behind it and the white sleeve above. But Jean de Dinteville's fingers move as Holbein studies the case, breaking his concentration. He looks up. The ambassadors are whispering to each other and Holbein sighs. He asks them not to talk while he is working. He needs total concentration to make this his best painting ever. When he has finished the dagger, he will make the sundials in the painting tell today's time and date: 10:30 a.m. on 11 April 1533.

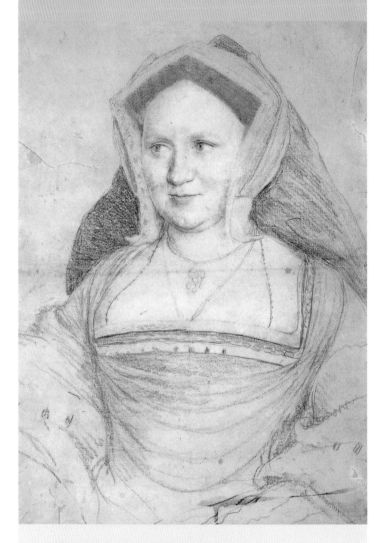

Mary Wotton, Lady Guildford

Lady Guildford was 27 when Holbein sketched her in preparation for her portrait. He always made drawings from life of the people he painted. In this chalk drawing Lady Guildford seems playful and fun, with pink cheeks and twinkling eyes. In the resulting painting she appears more serious.

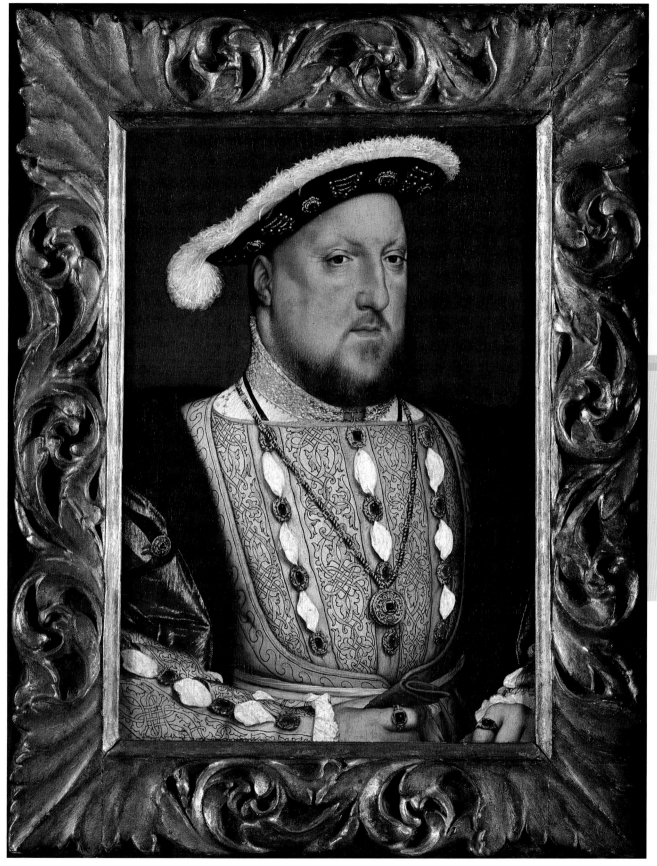

King Henry VIII

Just three years after painting *The Ambassadors*, Holbein painted this portrait of the King and became the King's painter. Henry VIII fills the small panel, his robes painted in real silver and gold. This is a painting of an icon — the King of England and the head of the Church of England. Yet his face is highly detailed. His cheeks seem flushed and there are wrinkles around his eyes. He is, Holbein suggests, a man as well as an icon.

want to see more?

www.artcyclopedia.com/
artists/holbein_the_younger
_hans.html

www.abcgallery.com/H/
holbein/holbein.html

www.ibiblio.org/wm/
paint/auth/holbein

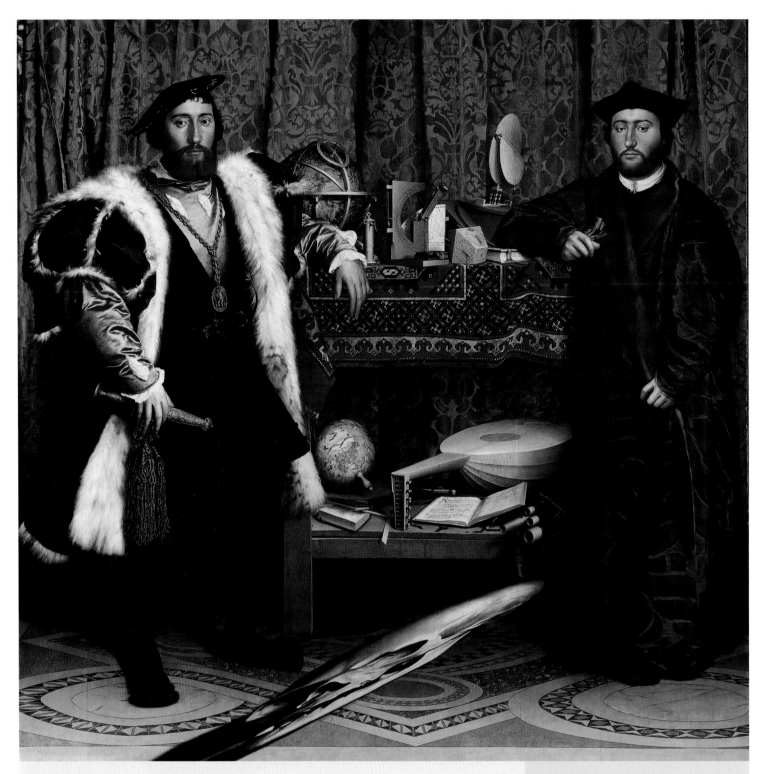

The Ambassadors

There are lots of clues about the two ambassadors in this painting. Jean de Dinteville's age is inscribed on his dagger – he is 29 – and the young bishop's age of 25 is written on the book he leans on. Their love of mathematics, music and astronomy can be seen from the instruments that surround them. This painting also points out that material objects and human life do not last forever: a giant skull stretches across the floor. It only looks like a skull when seen from the extreme right-hand edge of the painting. This painting may have hung on a staircase so the skull came into view as one passed by.

WHY DON'T YOU?

Make a detailed portrait of someone you know. Find pictures of their favourite things and stick them on the artwork.

HANS HOLBEIN THE YOUNGER

Hans Holbein the Younger (c. 1497–1543) was born in Germany and trained in Switzerland but spent much of his life working in England. He was a talented portrait artist, and also designed jewelry, gold and silver objects, book illustrations and wall-paintings.

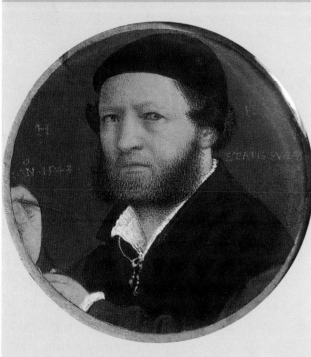

Self-portrait miniature, 1543

It is just after eight in the morning on the 11th of April, and Holbein is waiting for two men to arrive so he can finish off their portrait. They are both **ambassadors** of France, not yet thirty years old but already very powerful. Holbein has moved a table into position, and covered the top with a rich carpet. On it he has arranged scientific equipment borrowed from his friend Nicolaus Kratzer, the King's astronomer. Underneath Holbein has placed a globe and a stringed instrument called a lute. He wants these objects to show how educated the ambassadors are. Jean de Dinteville, on the left, is a French aristocrat. Georges de Selve, on the right, is the Bishop of Lavour, whose visit to London is the reason the men have decided to have their portrait painted.

Holbein has been known as a master of portraiture ever since he first visited England. Ten years previously he had painted three portraits of his friend Erasmus, an important scholar in Basel, Switzerland. When Holbein told Erasmus he needed to travel to England to look for work, Erasmus wrote to an influential English friend, **Sir Thomas More**. Holbein ended up staying in England with More for two years. Erasmus also sent one of Holbein's portraits of

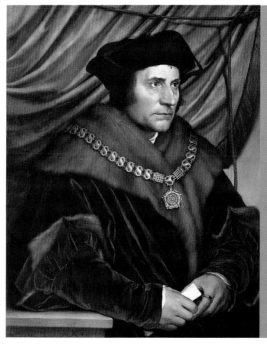

Sir Thomas More

Holbein was exceptionally good at paying attention to detail and capturing the likeness of his sitters. Look at the silvery stubble on More's chin, his tense brow and far-away look that suggests he is a thoughtful man. He wears the gold chain of the Lord Chancellor over a fur robe, and the richness of his red velvet sleeves makes you want to touch them.

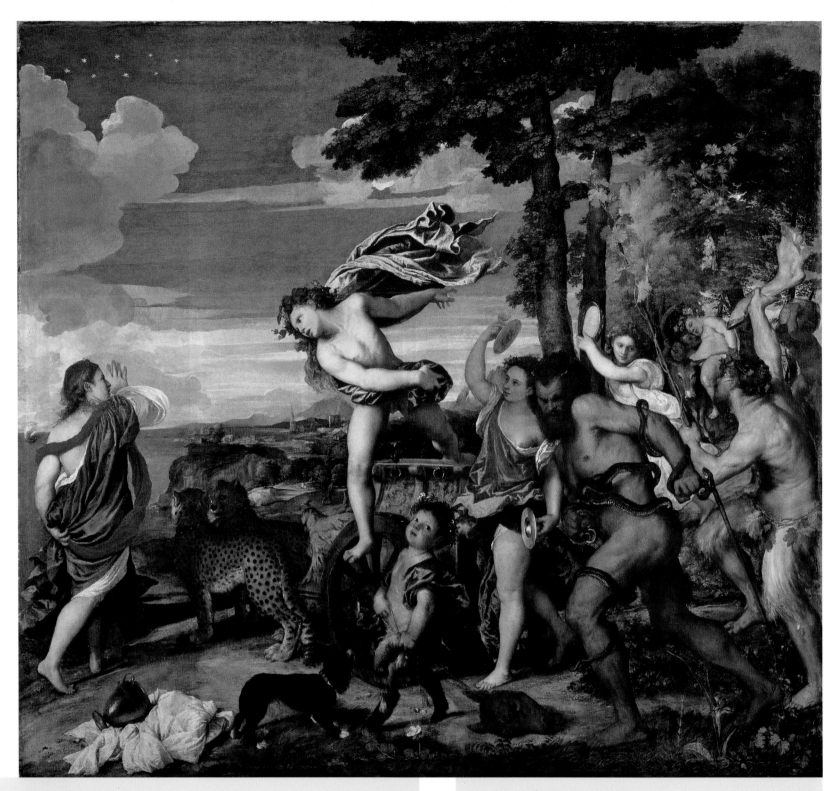

Bacchus and Ariadne

This painting shows a mythological scene. The god Bacchus leaps from his chariot to comfort Ariadne, the King of Crete's daughter, who has been abandoned on the island of Naxos. It is a very detailed painting and was part of a series for the Duke of Ferrara's study. Bacchus's chariot is pulled by two cheetahs, who seem to have frightened Ariadne. Titian drew the cheetahs from life as the Duke of Ferrara had a pair in his private zoo. The little dog in the middle may also have belonged to the Duke.

WHY DON'T YOU?

✱ Draw a picture of someone famous, or someone you admire.

✱ They can be real or imaginary, alive or dead. Try and make them look heroic!

The Assumption of the Virgin

The painting at the bottom of the Toledo altarpiece was the biggest El Greco had ever made at that time. It shows his love of colour and the angular, stretched bodies that were to become more and more exaggerated as he got older.

Did you know?

✳ El Greco demanded lots of money for each painting, and often filed lawsuits to get his patrons to pay up.

✳ He liked to live in palaces and would pay musicians to play while he ate. Other Toledo artists thought he was a show-off.

The Burial of Count Orgaz

The boy at the front of the picture is El Greco's son, Jorge Manuel. He was 8 years old when this painting was started. He looks out at us and his hand directs us to the main subject of the painting, the dead Count. The Count was a legendary figure, said to have given very generously to the church. In the painting, Jorge, like everybody else, is wearing contemporary clothes, even though the Count would have died long ago. El Greco wants to imply that the moral of the legend is still current, and people should still give to the church, as Count Orgaz did. If they do, he implies, their souls will also rise up to heaven.

The Adoration of the Shepherds

Look how tall and thin El Greco's figures have become in this late painting, and how dramatic it seems. The kneeling figure at the front is thought to be El Greco himself. Artists often included themselves in paintings that were destined for their own tombs, as this one was.

Want to see more?

www.artcyclopedia.com/artists/greco_el.html

www.ibiblio.org/wm/paint/auth/greco

www.abcgallery.com/E/elgreco.html

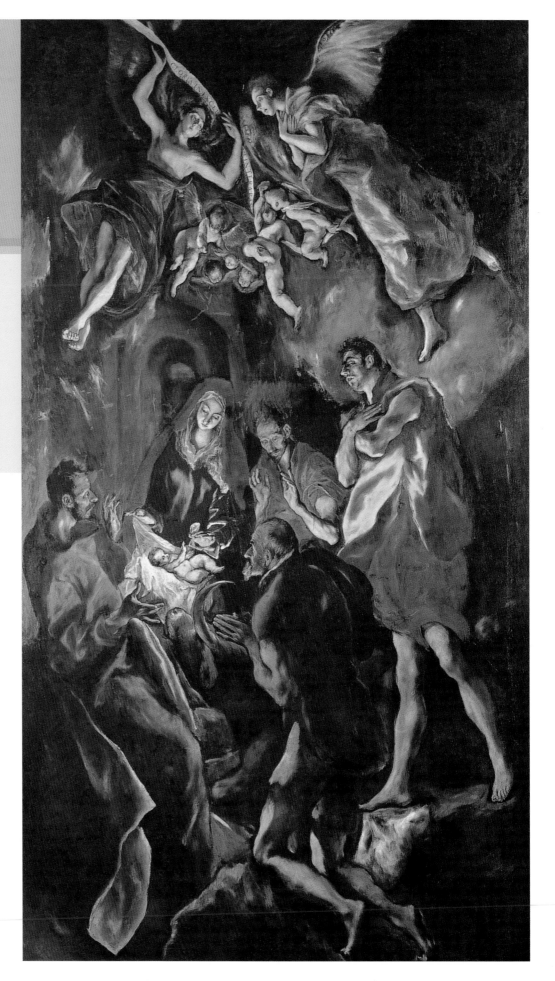

El Greco had moved to Toledo from Rome in Italy. But he wasn't Italian, and he wasn't Spanish either. He was in fact Greek. When he was 25 years old, he had left his home island of Crete to work in Italy, in Titian's studio in Venice (see page 28). His real name was Domenikos Theotokopoulos, but no one could say that in Italy or Spain, so he soon became known as El Greco, 'The Greek'.

While in Venice he admired the rich colour of Titian's paintings, and then when he moved to Rome he liked the fashion for painting bodies long and emotions strong to make paintings dramatic. By the time he arrived in Spain, he had a unique style and expected to be treated as a great artist.

At the height of his powers, around 1590, he was painting works such as **Nobleman with his Hand on his Chest**. But now times have changed, and El Greco's painting style is considered too over-the-top. His way of painting religious themes, as featured in *The Burial of Count Orgaz*, has also become old-fashioned. Younger artists who have moved to Spain are now getting all the big commissions.

Still, El Greco completes just about enough private religious works to pay the rent. In his grand apartment he hears a knock at the front door, and Jorge Manuel opens it. The patron is here. El Greco can't bring himself to see him, so he tells his son to look after him as he is too ill. Jorge closes the door softly.

Despite it being a sunny day, El Greco sits in his room with the shutters closed. The room is dark. He often likes to sit like this, dreaming and imagining. He prefers to paint things he sees inside his head than things he can actually see in real life. The painting he is working on at the moment – **The Adoration of the Shepherds** – started out this way, with an inner vision, as did many of his earlier works.

El Greco doesn't care that he is seen as out of touch. He is 72 years old and working on the painting that he wants to hang above his own tomb. As he slowly stands up, he thinks he must finish it soon, before he can no longer hold his brush.

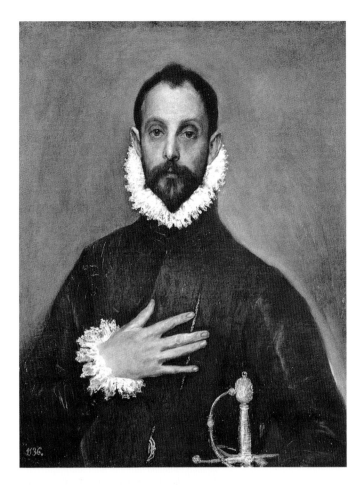

Nobleman with his Hand on his Chest

El Greco's portraits show that the distorted figures in his altarpieces were deliberate – he was quite capable of painting realistic likenesses with the figure more in proportion like this. The knight's eyes look through us and his cheeks glow with life. Even so, this nobleman seems to have a long, thin face and fingers, in keeping with El Greco's overall style.

WHY DON'T YOU?

* Draw a distorted self-portrait, inspired by El Greco's long figures.

* Look at your reflection in the back of a large spoon. It will look stretched and funny!

* How does the distortion change your appearance? Is your nose, or your chin, very long? Does it make you seem happy or sad? Draw what you see.

CARAVAGGIO

1602

Michelangelo Merisi, later called Caravaggio (1571–1610), was highly admired for his realistic yet dramatic paintings, but he also had a hot temper and was often in trouble. His style went on to influence a whole generation of artists across Europe, known as Caravaggisti.

Caravaggio bends down to remove a leaf from his boot. It is September and he is standing in the Contarelli Chapel in the San Luigi dei Francesi church in Rome, Italy. The chapel was paid for by the French Cardinal Matthieu Cointrel – or Contarelli in Italian – who left money for it to be decorated when he died. Caravaggio first worked on this chapel ten years ago, when he helped the fresco painter Giuseppe Cesari to paint the ceiling. Cesari had also been asked to paint the walls with scenes from the life of St Matthew, but luckily for Caravaggio he had been too busy to get around to it.

After years of waiting for Cesari to paint the walls, the church decided to ask Caravaggio to do it. They asked him because at the time he was working for Cardinal Francesco Del Monte, and Del Monte had just been put in charge of the money to finish the chapel.

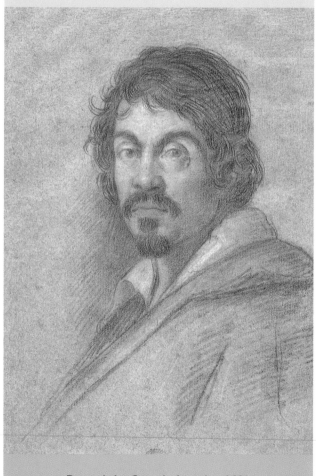

Portrait by Ottavio Leoni, c. 1621

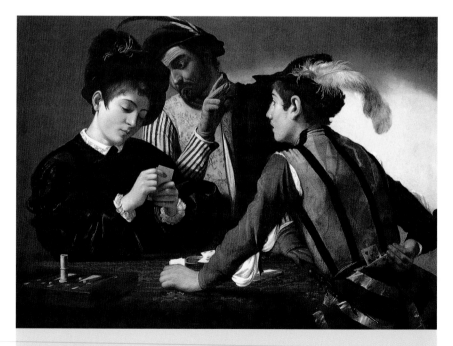

The Cardsharps

This early painting of Caravaggio's shows two card cheats preying on a wealthy innocent boy. The cheats' outfits seem expensive at first glance, but the man at the back has holes in his gloves and the boy who is taking an extra card from his belt has sleeves that are coming away from his stripy top.

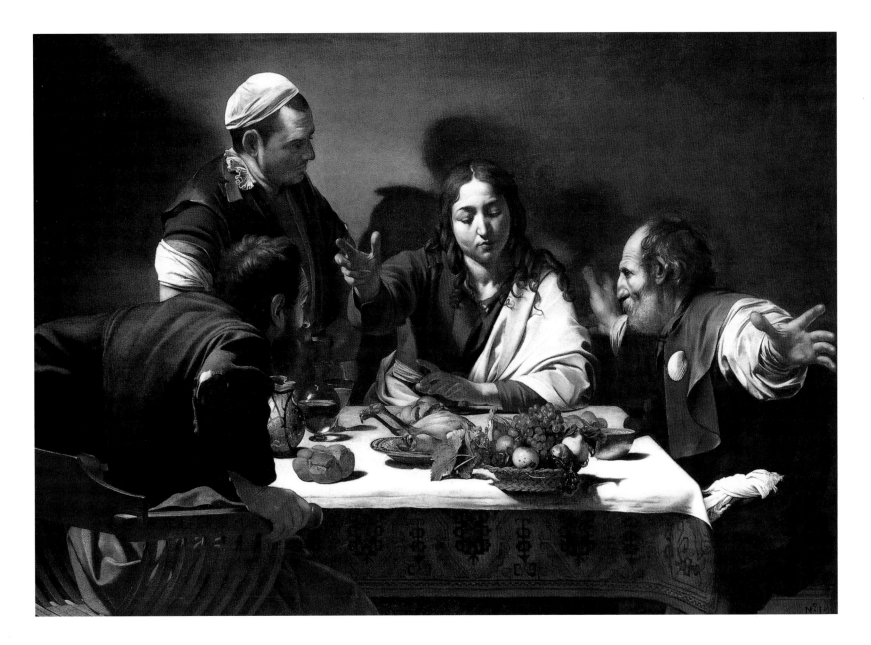

Caravaggio had been lucky to meet Del Monte. When Del Monte had bought his painting **The Cardsharps**, Caravaggio had been living in poverty. But the Cardinal was so impressed with the painting that he offered Caravaggio a room in his palace, all the food he could eat and a salary. In exchange the artist painted pictures for him.

After years of struggling to make it as a painter, it looked as if Caravaggio was about to become very successful. People were amazed by how realistic the figures he painted seemed to be, their hands and elbows jutting out, as in **The Supper at Emmaus**.

Sometimes, however, people felt Caravaggio went too far with his realism, and they rejected paintings they found unacceptable. Caravaggio, standing in the Contarelli Chapel, watches as one of his paintings of St Matthew is lifted into place above the altar. His first attempt at this painting was rejected, so he had to try again.

The Supper at Emmaus

In this painting Caravaggio has recorded the moment when two of Jesus's disciples realize it is Jesus blessing their bread, even though they saw him die the week before. One of them throws his arms out wide, almost touching us, and the other looks set to leap out of his chair. The bowl of fruit and the roast chicken show how good Caravaggio was at still lifes.

Did you know?

In 1606 Caravaggio killed a man in a fight after a tennis match. He spent the rest of his life on the run.

WHY DON'T YOU?

Paint something so it is as realistic as a photograph. Try and include shadows and tiny details.

The Conversion of St Paul

This painting still hangs in the Cerasi Chapel in the church of Santa Maria del Popolo, Rome, alongside *The Crucifixion of St Peter*. Look at the veins in St Paul's servant's legs, and look at the horse's coat. Caravaggio painted as much as he could from life and never idealized people or objects. This was revolutionary at the time.

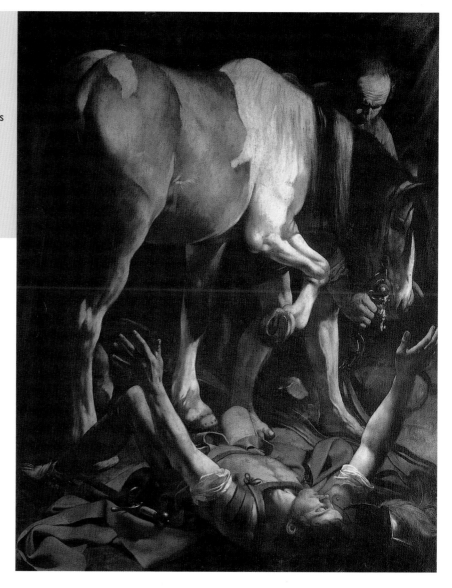

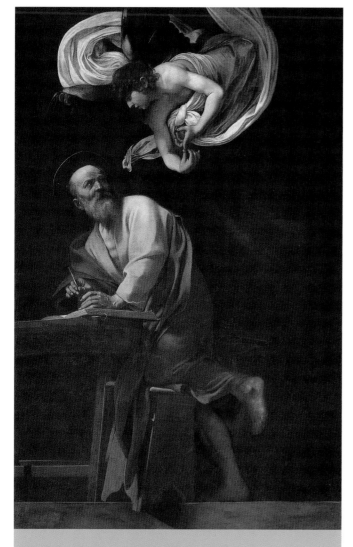

The Inspiration of St Matthew

Many of Caravaggio's paintings have dark backgrounds. They were often placed in gloomy churches, and by continuing the darkness into the paintings Caravaggio made his figures stand out all the more, particularly when he clothed them in bright colours, as in this painting.

Both versions of **The Inspiration of St Matthew** show the saint being helped by an angel as he writes his gospel. But the first version showed Matthew with the wrinkled brow and dirty toenails of a workman. In the second version Caravaggio made him look more scholarly in a toga. This second painting was accepted. Caravaggio was very angry when his first work was rejected, and ended up in a fight that evening. But now he is pleased because he has been able to sell the first painting to Cardinal Giustiniani.

Caravaggio's paintings of St Matthew, and the success of other paintings – such as **The Conversion of St Paul**, which is also very realistic – will lead him to receive commissions for more works.

For now, he looks up at the two he painted for the side walls of the Contarelli Chapel. He finished them two years ago. When he started the one called *The Martyrdom of St Matthew*, he couldn't get the size of the figures right, as he had never painted anything that

big before. In the end he stopped working on it and concentrated on **The Calling of St Matthew** instead. Matthew was a tax collector before Jesus asked him to become one of his disciples, and Caravaggio was asked to paint Matthew doing his job. He shows him sitting at a table surrounded by hangers-on, counting money. Most painters of the time would have dressed Matthew in an ancient costume, a toga like the one St Peter wears on the right. But Caravaggio chose to dress Matthew, who points to himself, in expensive and trendy clothes. He wanted the scene to seem as lifelike as possible. He even made sure the light in the painting came from the same direction as the window in the chapel. Caravaggio now looks up at that window and smiles. He has done a good job.

The Calling of St Matthew

On the right stands Jesus behind St Peter. Jesus raises his hand and points at the bearded Matthew, who in turn points at himself. Caravaggio uses strong lighting to emphasize the drama of the scene. The light follows Jesus's hand and illuminates Matthew's face.

Want to see more?

www.artcyclopedia.com/artists/caravaggio.html

www.ibiblio.org/wm/paint/auth/caravaggio

www.phespirit.info/pictures/caravaggio

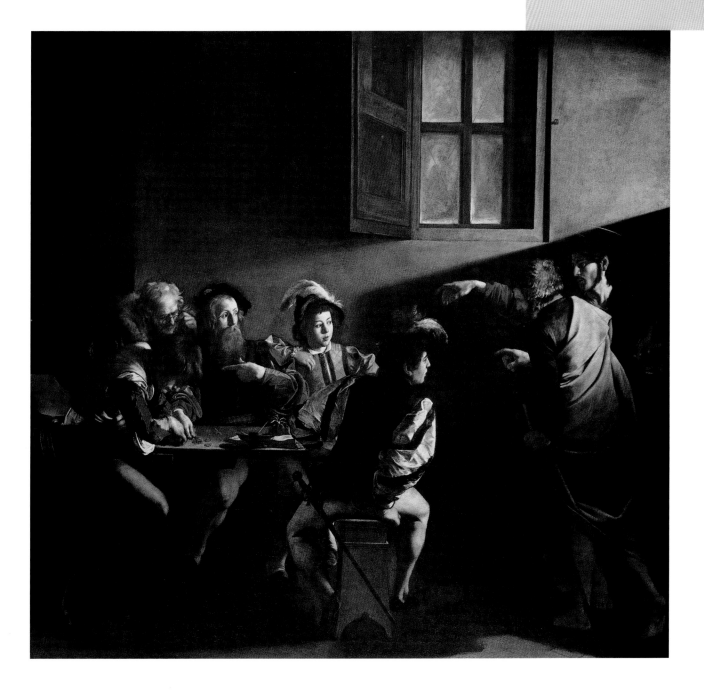

ARTEMISIA GENTILESCHI

Artemisia Gentileschi (1593–c. 1656) is one of the most important painters of the seventeenth century. She led the way for women artists, and painted strong heroines who were always at the heart of the action in her work.

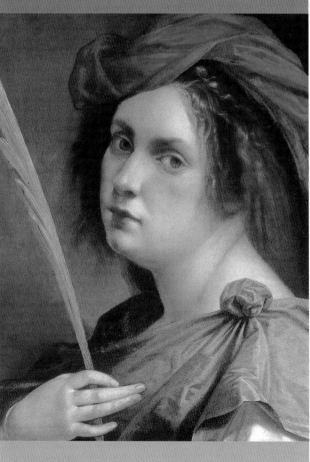

Self-Portrait as a Female Martyr, c. 1615

1638

Artemisia Gentileschi watches her father Orazio as he hurries across the black-and-white marble floor of the Queen's House in Greenwich, London. He wants to talk to two workmen who are about to start sticking his *Arts and Sciences* painting to the ceiling. Artemisia has been enjoying helping her father since she has been in London. He is over 70 years old now, and before her trip to England Artemisia hadn't seen him for a long time.

She has been called to London from Italy by King Charles I. Her father is one of the King's court painters, and now the King wants to buy a work of hers. He is particularly interested in her **self-portrait**, where she has dressed herself up to represent Painting.

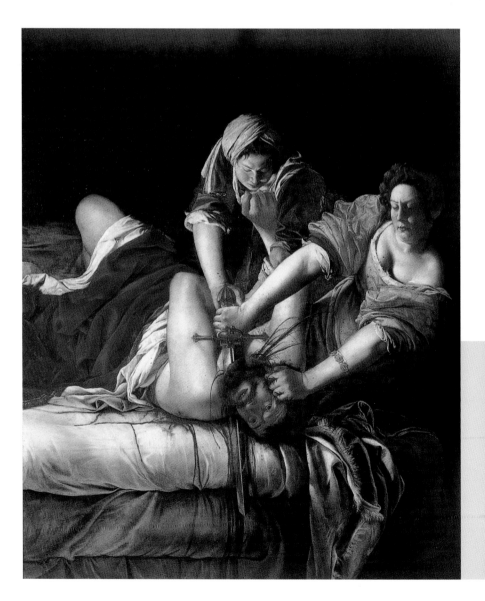

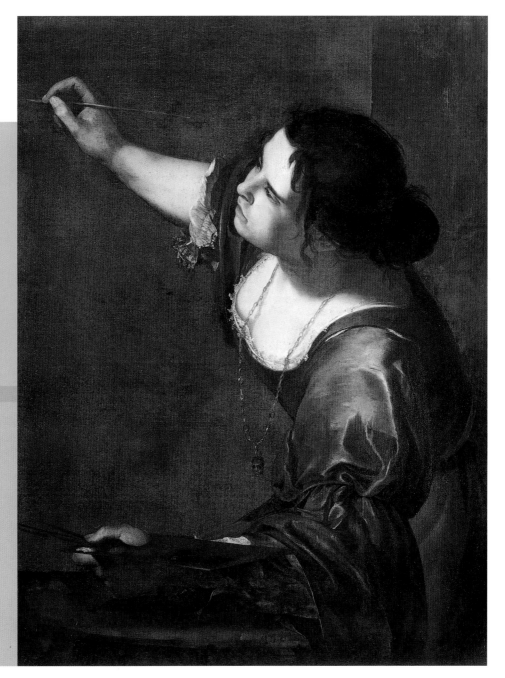

Self-Portrait as the Allegory of Painting

In this self-portrait Gentileschi has used a book on symbolism for artists to turn herself into a representation of Painting. She wears a gold chain with a mask on it to show that she imitates things, and her hair is messy to suggest the creative frenzy of painting. She wears a brown apron over her beautiful dress to protect it, and she holds a brush and palette.

Did you know?

* Artemisia Gentileschi used several mirrors to create her self-portrait to make it seem as if she was totally absorbed in painting.

* She was good friends with the scientist Galileo Galilei, whom she met in Florence.

Judith Slaying Holofernes

Judith, a Jewish widow, is invited to a banquet by the Assyrian general Holofernes. Their two countries are at war. Judith wears her best gold dress and jewelry. Holofernes drinks too much and falls asleep on his bed. Judith picks up his sword, asks God to give her strength, and cuts off his head. The story comes from the Old Testament of the Bible.

Although at the time it was difficult for a woman to be a successful artist, Artemisia's father supported her and she became very successful. She was the first woman member of the Academy of Drawing in Florence. She also produced many works for the ruling Medici family, including the gory **Judith Slaying Holofernes**.

In many of her paintings, Artemisia was influenced by the work of Caravaggio (see page 40). She loved the way his paintings were so realistic, and the way he told dramatic stories by using strong light and dark shadows. Artemisia's father, a friend of Caravaggio's, was so influenced by him that he was known as a Caravaggisti.

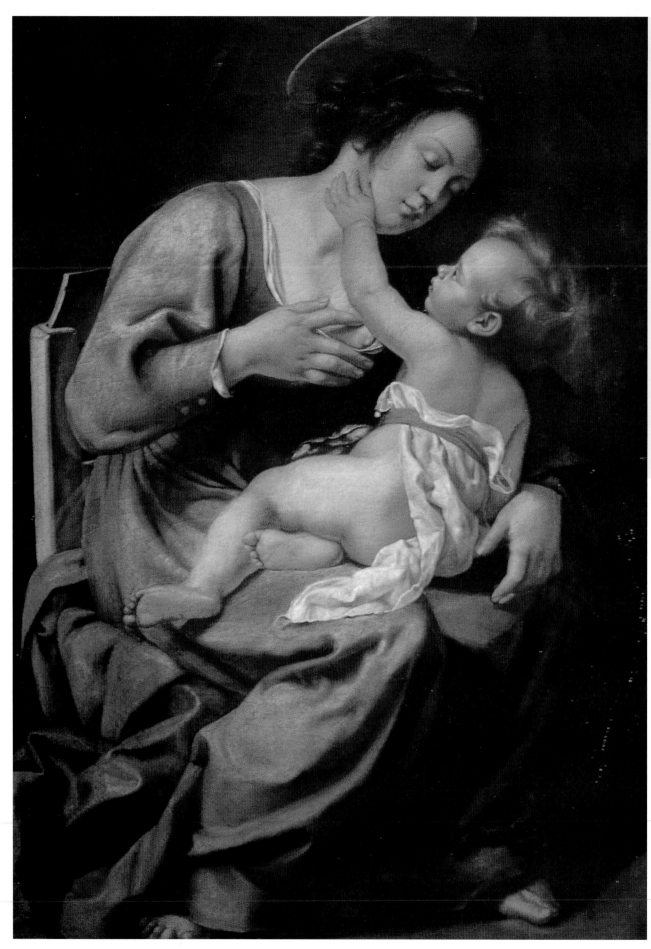

Madonna and Child

This is one of Gentileschi's first paintings, completed when she was a teenager. It is a very natural scene. Jesus's mother Mary is sitting on a low chair trying to feed him while he is distracted and plays with her hair.

● ● ● ● ● ●

Want to see more?

www.artemisia-gentileschi. com

www.artchive.com/artchive/G/ gentileschi.html

http://gallery.euroweb.hu/html/ g/gentiles/artemisi

In one of Artemisia's first paintings, **Madonna and Child**, the dark background and natural playfulness of the baby derive from Caravaggio's work.

In *Judith Slaying Holofernes*, she also followed Caravaggio, who had painted the same subject, in deciding to show the moment when Judith cuts off Holofernes's head in order to stop his war against her country. But unlike Caravaggio's heroine, who cuts off Holofernes's head at arm's length, Gentileschi's Judith is much more believable. Blood spurts from the man's neck as she grips his sword with her right hand. Her left hand presses down on his head, pinning him to the bed. Her body is twisted with the effort, and her maidservant also has to lean on Holofernes to hold him still.

Previously artists had painted the moment after Holofernes's death, when Judith's maidservant carries the head away in a basket. But even when Artemisia painted this moment she didn't lose any of the drama. In **Judith and her Maidservant** Judith still tightly grips the general's sword while her servant pulls a sack over his head. Judith raises her hand, and both women look beyond the candle on the table into the darkness of the tent, as if they have heard someone coming.

Gentileschi painted *Judith and her Maidservant* when she moved from Florence back to her native Rome, with her daughter Prudenzia. She left her husband – the artist Pierantonio Stiattesi – behind in Florence because, despite her success as a painter, he squandered lots of her money and they were constantly in debt. Gentileschi had had enough. Fortunately, it had been a good move for her, and now she was even more successful than before. But still she had never dreamed that she would one day be asked to travel to London and talk about her paintings with the King of England. Gentileschi smiles and goes to her father, offering her arm for him to lean on as they walk out of the Queen's House, towards the river Thames.

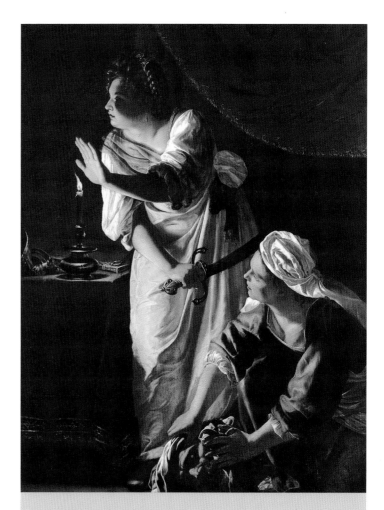

Judith and her Maidservant

In this painting Judith has already cut off Holofernes's head, which lies on the floor. She has raised her hand to silence her maidservant, as if she can hear something. Gentileschi intensifies the drama of this painting by lighting it with a single candle. Judith's hand casts a heavy shadow over her face, and we share her fear of what lies out there in the darkness.

WHY DON'T YOU?

✳ Make a postcard to send to someone who lives in a different city.

✳ Draw a postcard-sized drawing on some strong card.

✳ On the back of the postcard write your message, write the name and address, add a postage stamp and mail it!

Gian Lorenzo Bernini

Gian Lorenzo Bernini (1598–1680) is Italy's most famous seventeenth-century sculptor. He also found time to paint, put on plays, and design buildings and fountains.

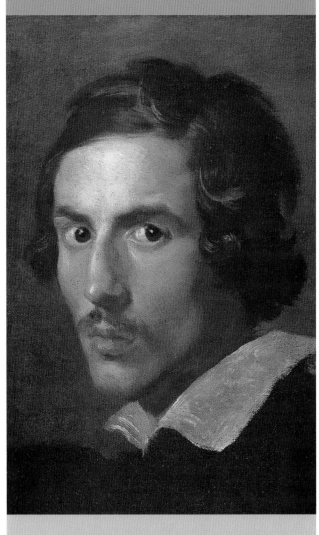

Self-Portrait as a Young Man, c. 1620

1651

It is late afternoon, and a small, thin man is standing under scaffolding in a side chapel in the church of Santa Maria della Vittoria, Rome. It is Gian Lorenzo Bernini, Rome's most famous sculptor. He has designed the whole chapel himself, including all the columns and marble panels, the ceiling painting, and the central sculpture. It is this sculpture that Bernini is now admiring. He thinks it could possibly be the most beautiful thing he has ever created.

Bernini is used to working on a large scale, and can turn his hand to anything. As well as making sculptures and designing buildings, he has created **fountains**, and even staged plays.

In the chapel it is getting darker. Bernini's new sculpture will soon become hard to make out in the shadows. The sculptor goes over to his bag and pulls out an apple. Despite being wealthy, thanks to his sculptures, he has a simple life and eats mainly fruit.

When he was starting out as a sculptor, he carved figures. But now he enjoys being asked to design whole buildings. It was Cardinal Cornaro who asked him to decorate the chapel he is now standing in, and for decades he has been responsible for much of the interior decoration of the Pope's impressive church, St Peter's.

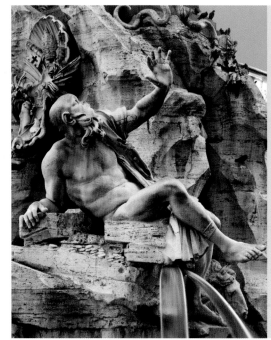

Four Rivers Fountain (detail)

Bernini designed this fountain (and its plumbing) for Piazza Navona in Rome. It features four world rivers – the Nile, Danube, Rio de la Plata and Ganges – represented by four figures. It is topped by an Ancient Egyptian obelisk, which was found nearby in pieces.

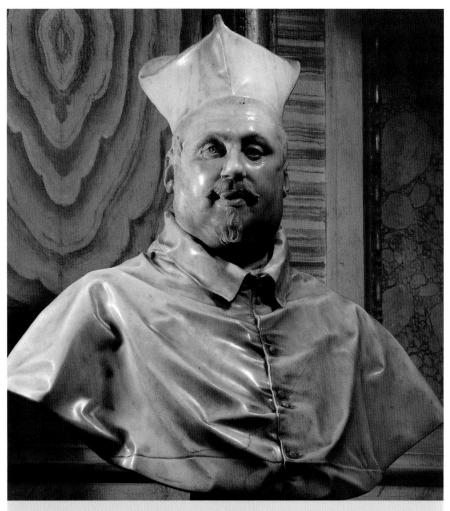

Cardinal Scipione Borghese: sketch, portrait bust and caricature

Fulvio Testi, a poet friend of Bernini's, said it looked as if this portrait bust was alive and breathing. Bernini shows the Cardinal with his lips parted as if in conversation, and his head turned to look at someone to his right. Bernini's sketch shows his great skill at drawing, while his caricature shows a great sense of fun!

Bernini worked for eight popes in total, and made portrait busts of most of them. These are head-and-shoulders likenesses that record their subject's face. Unlike other sculptors of the time, Bernini wanted his portrait busts to seem alive. He would follow his subjects around for days, watching them as they went about their business. He wanted to get to know their faces and personalities. One of his patrons was **Cardinal Scipione Borghese**, who asked Bernini to make him lots of sculptures.

Bernini bites into his apple and looks around the chapel. A painter is busy covering the ceiling with angels. Marble panelling in yellow, green and grey lines the building, and two white marble panels hang high up on either side of the altar. Bernini has carved figures into these panels as if they were looking down from boxes at the theatre.

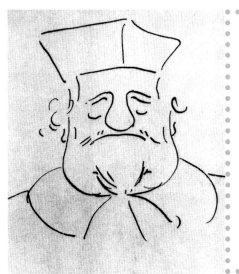

Want to see more?

www.artcyclopedia.com/
artists/bernini_gianlorenzo.
html

http://gallery.euroweb.hu/
html/b/bernini/gianlore/
index.html

Ecstasy of St Teresa

This is Bernini's masterpiece. It brings together sculpture, architecture, painting and decoration. Bernini wanted to create a spiritual experience for the viewer when they entered the chapel, similar to the experience felt by St Teresa in the main sculpture.

WHY DON'T YOU?

* Make a sculpture.

* Take some pipe cleaners or some plastic-coated garden wire.

* Twist your material to make the shape of a person. Are they standing, or sitting, or lying down?

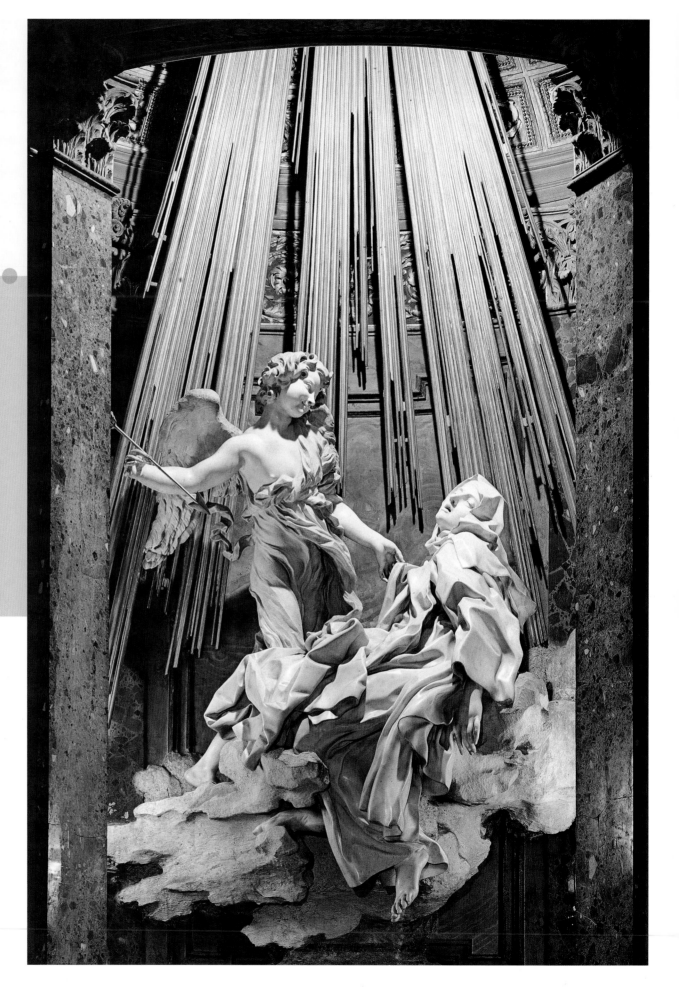

He has come a long way since his early sculptures. He was a child prodigy who received his first commission at the age of ten. He created a sculpture of **Amalthea**, the nanny-goat nurse of baby Jupiter. That was the first of many commissions for the Pope's family. Cardinal Scipione Borghese also asked him to make a sculpture of **David** from the Bible story David and Goliath.

But now Bernini has created his greatest work. In the middle of the chapel, behind the altar, twin pillars open up the back wall and reveal the **Ecstasy of St Teresa**. The saint is shown being visited by an angel who repeatedly pierces her heart with a golden arrow and fills her with the love of God. The saint and the angel appear against a backdrop of golden rays that catch the light from the window above them. St Teresa seems to be in a trance – her eyes are nearly shut and she falls backwards on a cloud. The angel seems to have flown down from the ceiling where his friends circle.

Bernini takes a final bite of his apple. He is going to go to church now, as he does every night. While he makes his way out, he calculates that the chapel should be finished in a year's time. He smiles with pride. It will be hard to match this, he thinks.

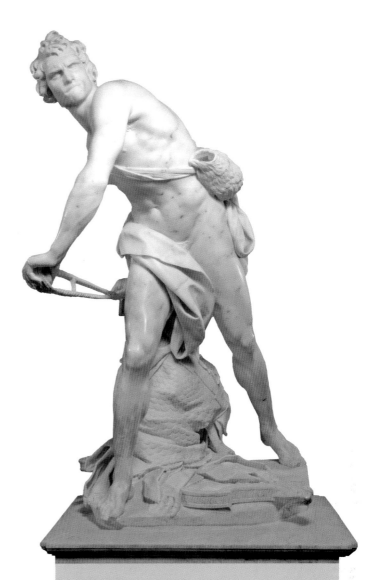

David

Compare this David to the one by Michelangelo on page 22. Bernini's version is all action. David is just about to let go of his slingshot. Look at the twist in his body, his frown of concentration, his lips bitten together. His legs are so wide apart his toes curl off the edge of the plinth.

Did you know?

* Bernini carved his first sculpture when he was 8 years old.

* He was knighted by the Pope for his lifelike portrait busts when he was only 22.

* He had eleven children, some of whom also became sculptors.

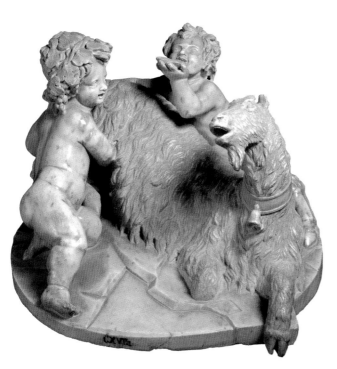

The Goat Amalthea with the Infant Jupiter and a Faun

Bernini made this when he was 10 years old. It is carved out of marble, a very hard stone that has to be chiselled and hammered to chip pieces off in order to create a work of art out of it.

DIEGO VELÁZQUEZ

Diego Rodríguez de Silva y Velázquez (1599–1660) painted portraits of the King of Spain and his family for over thirty years. His most famous work is *Las Meninas* ('The Maids of Honour'). He was highly praised during his lifetime, and was made a knight.

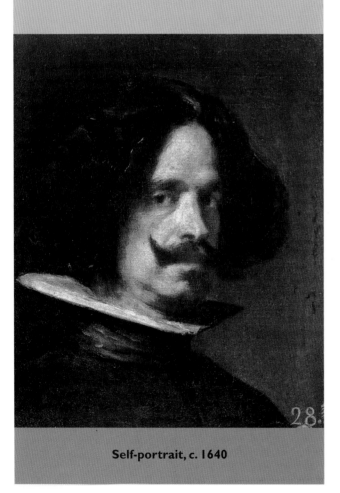

Self-portrait, c. 1640

1656

King Philip IV of Spain is standing in his palace, the Alcázar, in Madrid. In front of him is a wooden door, and beyond it is Diego Velázquez's studio. When the King was young, he would sit and watch the artist at work most days. But now he is over 50 years old. He is not so eager to be painted, even by his friend.

Velázquez has been the only artist allowed to paint the King since he came to the throne as a 16-year-old boy. Velázquez was young then, too, in his early twenties. But now the King knows he has aged. His eyes are drooping and he has the start of a double chin. He takes a deep breath and enters Velázquez's studio.

There is a big picture leaning against the wall. It is called **Las Meninas**. The King can see that Velázquez has painted himself in the picture. The artist is dressed in black and holding a palette and paintbrush. The King's little daughter **Margarita** is also in the picture. She is very pretty, with long wavy blonde hair and big eyes. The princess is wearing a white dress and she is surrounded by her two maids of honour and a female and male dwarf entertaining her.

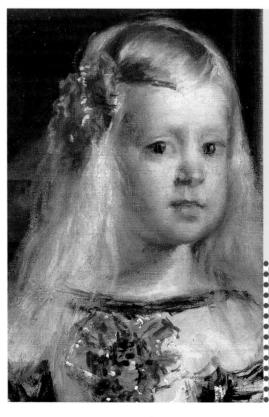

Las Meninas (and detail)

The title of this painting means 'maids of honour'. The maids of honour look after the little girl in white. She is the Infanta Margarita, or Princess Margarita. The maids stand on either side of her in the painting. It is considered Velázquez's finest work.

Did you know?
The Infanta Margarita was only 5 years old when she was engaged to be married!

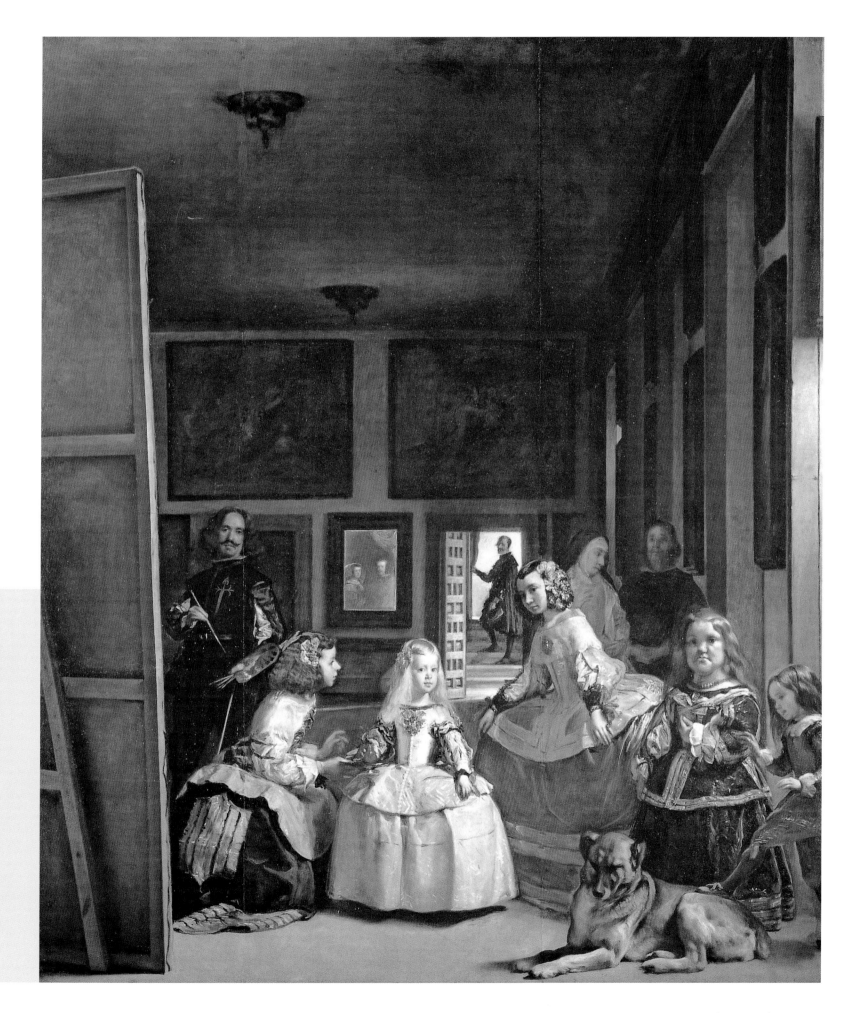

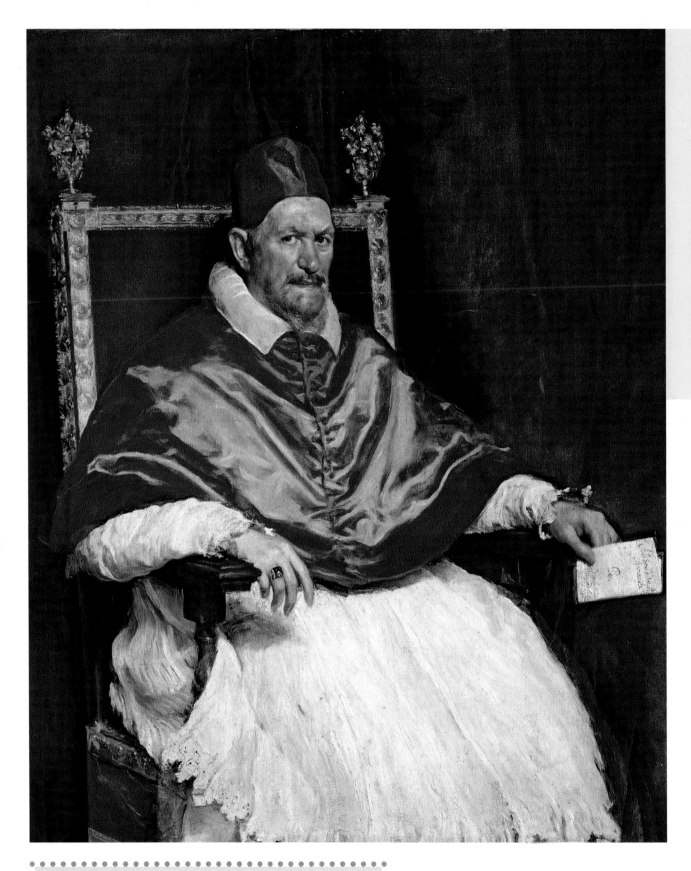

Pope Innocent X

King Philip IV sent Velázquez to Italy to buy paintings for the royal palace. Velázquez stayed in Italy for three years. While he was there, he painted the Pope. The Pope said this portrait was too truthful, meaning it showed his true character. The Pope was very observant and untrusting of others. Velázquez suggests this through his raised eyebrows and direct stare.

want to see more?

www.ibiblio.org/wm/paint/auth/velazquez

www.artcyclopedia.com/artists/velazquez_diego.html

When you first look at the princess's dress, it seems to be made from shimmering satin. But look closer and you see big zigzags of white paint smeared on top so it looks as if light is reflecting off the shiny dress. This bold way of painting was greatly admired by Édouard Manet (see page 76) centuries later.

Back in the studio the King steps away from the painting. Velázquez has nearly finished work on it, and the King wants to have it in his bedroom when it is done. He is fascinated by it.

The artist in the painting seems to be working on a huge canvas, but what can be on the canvas? If you look at the back wall of the painting, you will see a mirror. Reflected in it is the King with his wife, Queen Mariana. If Velázquez is painting the king and queen, then that would explain how they can be reflected in the mirror behind him. But at the same time Velázquez has also painted Margarita. If he was painting the princess, he would have to be standing in front of her, not behind her. The painting is a puzzle, and the King likes that.

Velázquez has been a brilliant painter for a very long time. Before he started painting the King in Madrid, he lived in another Spanish city, Seville, with his wife and their two daughters. He painted scenes of everyday life, such as an **old man selling water** and a woman cooking eggs. Even though he painted poor people, he made them seem very dignified. He also painted very truthfully. When he first painted the King, he didn't make him more handsome than he was. What everyone loves about Velázquez's portraits is that they look so lifelike and full of character.

Velázquez does many jobs for the King, including looking after the royal collection of paintings. He doesn't have much time to paint anymore. He is also a slow worker, completing only six paintings a year, even though he has lots of assistants. But the King values him very highly. At the moment the King is trying to persuade **the Pope** to give Velázquez a knighthood.

In the studio Velázquez coughs. He is ready to begin a new portrait, and asks the King to stand by the window where the light is strongest. The King smoothes down his hair, straightens his gold chain and looks his old friend in the eye.

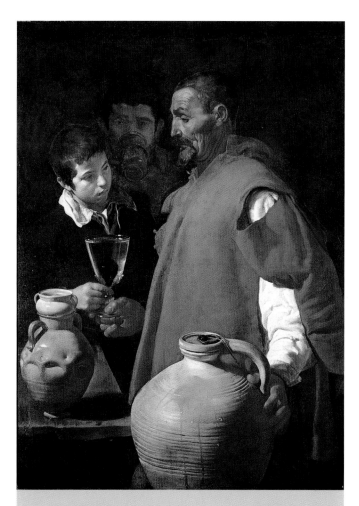

The Waterseller of Seville

Velázquez painted this when he was 21 years old. It is called a *bodegone*, a type of painting that shows everyday scenes of eating and drinking. In this painting an old man gives a glass of water to a boy. Behind them, a man drinks another glassful. Look for the drips of water on the earthenware pot at the front.

WHY DON'T YOU?

* Make a picture that is a puzzle.

* Create your own jigsaw for your friends to figure out.

* Take an interesting picture, stick it carefully onto cardboard, then cut it into shapes that can be put back together again.

REMBRANDT

Rembrandt van Rijn (1606–1669) made his name as Holland's greatest portrait painter. He painted and made prints of himself throughout his life as well, in a variety of costumes and poses.

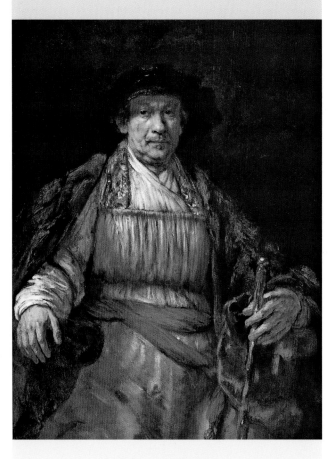

Self-portrait, 1658

1658

Rembrandt is 52 years old, and very poor. All the money he has made from painting the wealthy and important citizens of Amsterdam has gone. The artist has spent it on the big fashionable house where – now that his wife has died – he lives with his companion **Hendrickje**. He has also spent a lot of money on his collections of art and interesting objects. Soon he will have to sell all his things, and his house too, as he has been declared bankrupt.

Rembrandt was a clever boy, and by the age of 14 he was at university in Leiden, his home town in Holland. But after a few months he convinced **his mother** and father he really wanted to be an artist. He spent the next four years studying in the studios of local painters, and quickly became a successful portrait painter in Amsterdam.

Rembrandt also regularly painted himself wearing grand clothes and using props he had bought – armour, swords, gold chains. He had long curly hair, a round face, expressive eyes and a bulbous nose. Painting himself allowed Rembrandt to spend time studying how a face changed when it was happy or sad, angry or calm. It also showed others how good he was as a painter, because they could compare the painting to the real thing – the artist himself.

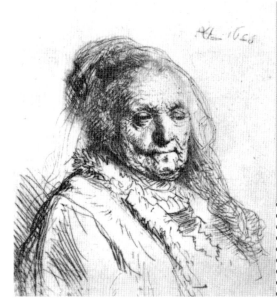

Rembrandt's Mother

Rembrandt liked to make drawings, paintings and etchings of older people. This sketch is of his mother. It is thought that she modelled for many of his works, including some famous ones such as *The Prophetess Anne* (1631).

Want to see more?
www.rembrandtpainting.net

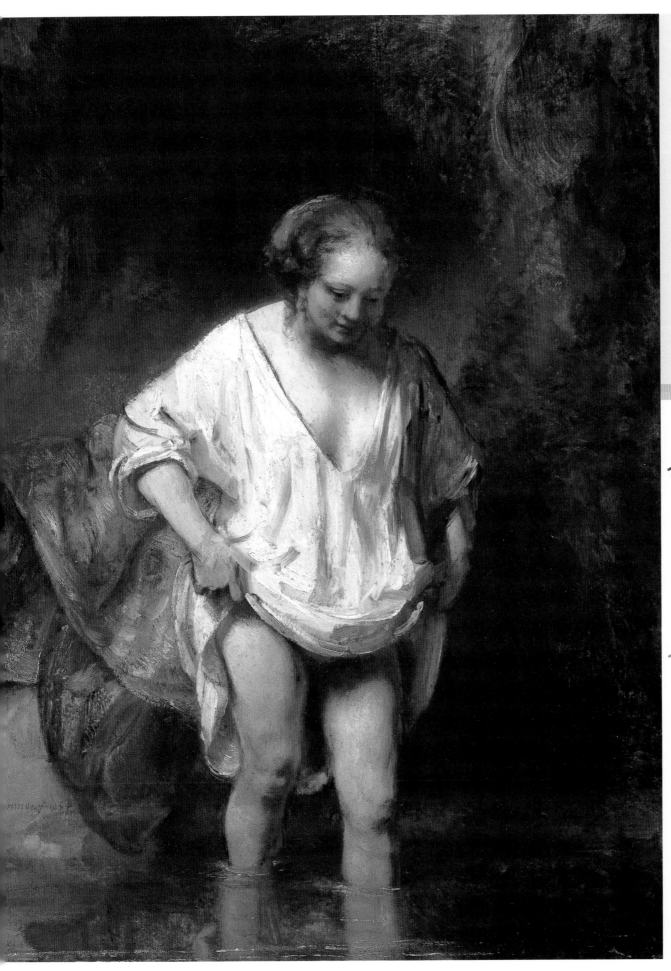

Hendrickje Bathing

This is a painting of Hendrickje Stoffels, who lived with Rembrandt after his wife died. The way it is painted is very different to Rembrandt's earlier work. Look at the broad brushstrokes and the thick paint on the dress. This gives the painting life and movement. At the time it was made, most people would have thought that a painting in this state was not finished. Rembrandt was very original and daring to experiment like this.

Did you know?

* Rembrandt kept a room full of interesting things, including costumes, trumpets, helmets, globes, shells, antlers, busts of Roman emperors and prints by his artistic heroes.

* Rembrandt and his wife Saskia had four children, but sadly only one, Titus, lived to become an adult. Titus and Hendrickje helped Rembrandt after he went bankrupt by selling his paintings for him.

Self-Portrait in Oriental Attire

In this self-portrait Rembrandt, aged 25, has painted himself as a king. He has copied the pose from a painting by his rival Peter Paul Rubens (*The Adoration of the Magi*, painted in 1617–18), to show that he is as good as Rubens and, like a king, very powerful and wealthy.

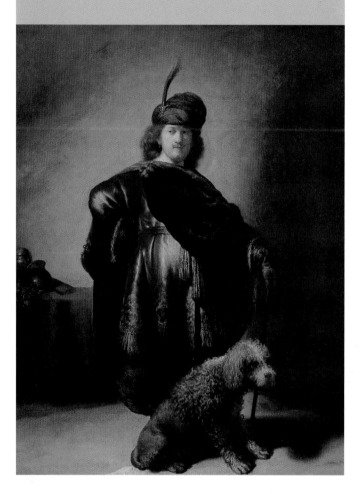

WHY DON'T YOU?

* Start a collection of interesting things. You could keep props for paintings like Rembrandt did.

* Or you could start a collection of postcards of your favourite paintings.

The Night Watch (detail)

A little girl stands among the military men and looks on with interest. She has a dead bird hanging from her waist. No one knows why, or why she is there. Her dress is blue and gold like the company's flag above her, and maybe she is a mascot for the group.

Now when Rembrandt looks in the mirror in his studio, he sees a man with sagging cheeks, a double chin and grey hair. The **self-portraits** he has made chart his journey through life.

The artist walks to the window. He can see another studio below, a long enclosed walkway where he painted his biggest work, **The Night Watch**, sixteen years ago. The canvas measured over 4 metres (13 feet) long and was twice his height. It was a portrait of Captain Banning Cocq and a group of wealthy men from Amsterdam. Years earlier, men like these had fought in wars as Holland struggled to become an independent country. Now the fighting was over and the men only paraded their weapons on ceremonial occasions. All eighteen men in the painting had paid Rembrandt in order to have their portrait included. You can see the captain in the middle,

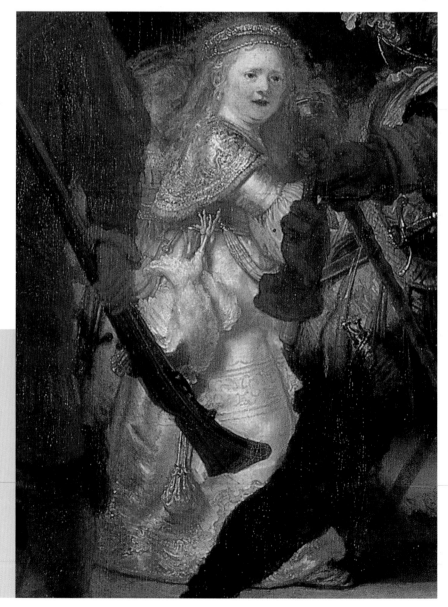

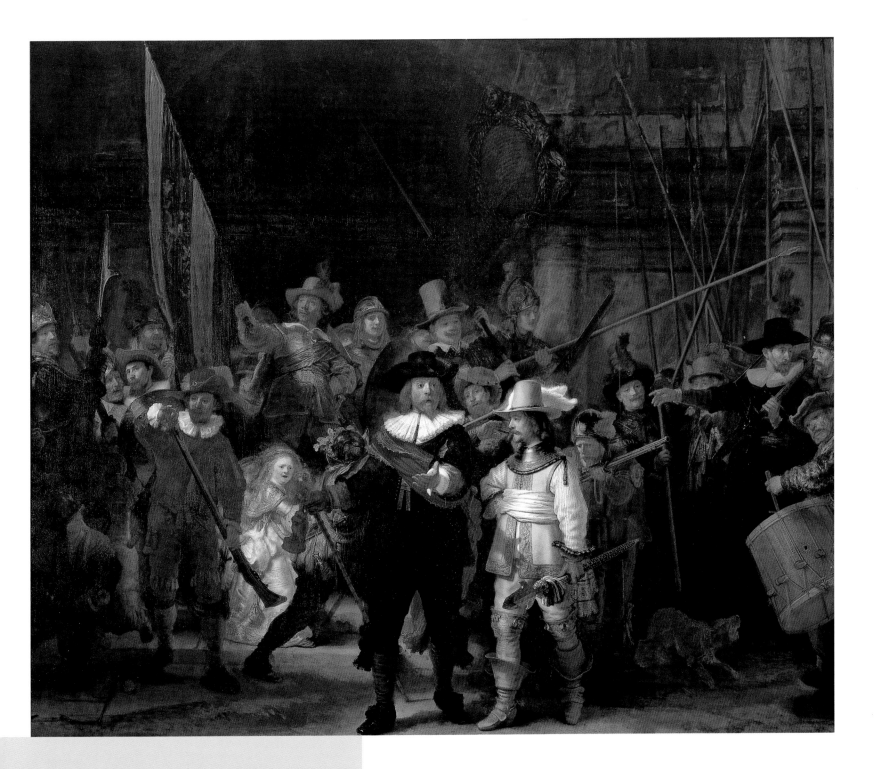

The Night Watch, or The Company of Captain Banning Cocq

This huge painting was not called *The Night Watch* until a long time after Rembrandt had died. Rembrandt had covered the painting in varnish to protect the surface, and over the years it had darkened until people thought the painting showed men on guard at night. Only when it was cleaned was daylight revealed. However, the popular title has stuck.

in black clothes with a red sash across his chest. His lieutenant is next to him in a fancy yellow costume, showing off his wealth and position in society. Other artists at the time arranged men into long lines (like a school photograph), but Rembrandt preferred to tell a story. The men wave flags and prepare their guns. The sound of drums fills the air. The group are on the move: look at the tassles on the captain's breeches swinging as he walks.

Rembrandt goes to the props in his studio. He chooses a gold costume, a red sash and a cane. He is going to paint himself again.

Francisco de Goya

Francisco José de Goya y Lucientes (1746–1828) is the greatest Spanish painter of his generation. As famous for his later imaginative works as for his portraits of the rich and famous, his skill with a brush brought everything he painted to life.

1800

It is mid-afternoon on a sunny day and Goya is eager to begin painting. He is about to start work on a portrait of the Spanish royal family, but he knows he won't be able to hear them coming through the door. For the last seven years, following an illness that nearly killed him, Goya has been totally deaf.

While he was ill, Goya had very vivid dreams and nightmares. Some of these inspired his first print series, **'Los Caprichos'** ('The Fantasies'), which he published a year ago. Afterwards he carried on painting portraits, but found that making prints helped him come to terms with being deaf.

Goya doesn't know it yet, but there are more troubled times ahead. In just a few years his country will be at war with France, the king will have to go into hiding, and Goya will lose his royal salary. When this happens, he will turn his attention to painting the madness of war, from the first battles in Madrid in *The Second of May 1808* and **The Third of May 1808** to a new print series, 'The Disasters of War', as well as paintings like *The Colossus*.

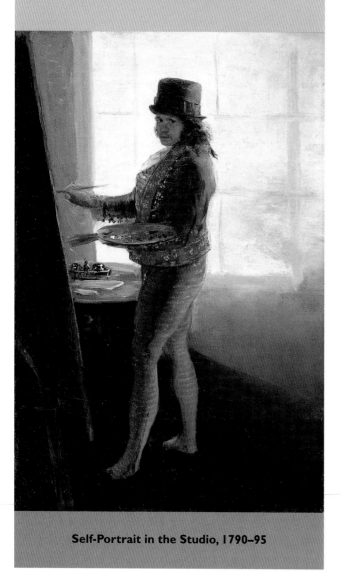

Self-Portrait in the Studio, 1790–95

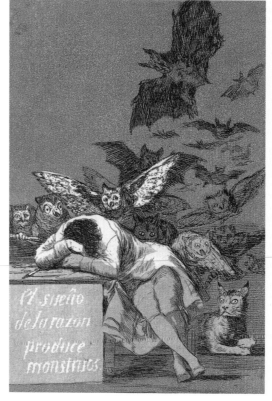

The Dream of Reason Produces Monsters, 'Los Caprichos'

This etching was one of eighty that Goya produced in his series 'Los Caprichos'. The series depicts a nightmarish view of society and features witches, skeletons and strange animals. As Goya aged, he created more works like this from his imagination. This etching suggests that these creatures have escaped from the man's mind when he fell asleep and are now tormenting him.

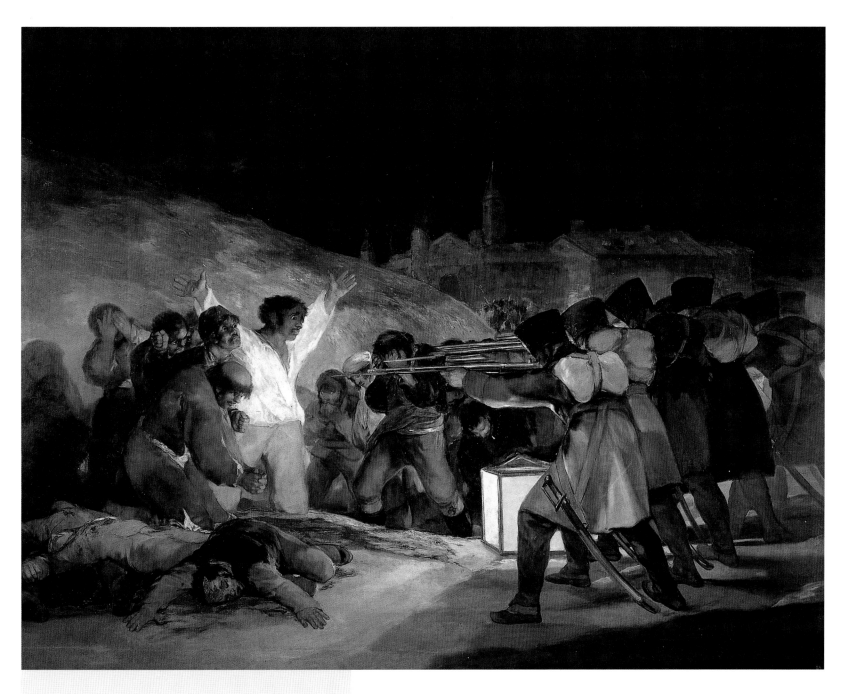

The Third of May 1808

This shows the first executions that took place in Madrid after the French invaded Spain. The faceless French firing squad were in action day and night. The lantern in front of them lights up the white shirt of the next victim, who kneels with his arms raised, his eyes pleading with the troops.

WHY DON'T YOU?

Draw a picture of something spooky –
a scary ghost, a blood-sucking vampire,
a wicked witch, a clanking skeleton.

But for now it is still 1800, and Goya is waiting in the Aranjuez Palace for the royal family to arrive. He has worked for the family for nearly fifteen years. When he first came to Madrid, he worked in the studio of a painter called Francisco Bayeu (and married Bayeu's sister Josefa), but in 1774 he was asked to help out with the tapestry designs for two of the royal palaces. He started working for King Charles III when he was 40 years old. King Charles IV came to the throne three years later, and Goya was promoted to First Painter – a great honour that came with a large salary. Both kings treated Goya well. At one point he had a golden carriage, one of only three in Madrid, and now Charles IV has just promised him a new house. At the moment he lives with his wife and son in a

The Family of Charles IV

A contemporary of Goya's said this painting made the king and queen look like the local baker and his wife who had just won the lottery. Goya was known for his mastery of brushwork that could make painted fabric seem expensive and jewels sparkle. But he refused to flatter his clients, even the Spanish royal family who were not known for their good looks.

Want to see more?

www.artcyclopedia.com/artists/goya_francisco_de.html

www.abcgallery.com/G/goya/goya.html

www.artchive.com/goya.html

house above a perfume shop, but he has left them at home to travel to this palace carrying his canvas, stretcher and materials.

Goya has painted the royal family many times. He has also made portraits of members of the aristocracy, including **Manuel Osorio Manrique de Zuñiga**, the little son of a Spanish nobleman.

But now the royals, all wearing their finest clothes, enter the palace room and take their positions. King Charles IV stands in his dark coat covered in medals and sashes, alongside his wife and their youngest children. His eldest son Prince Ferdinand, who is 17 years old, stands on his own. Behind them are the King's brother and sister and other family members. Goya has already completed ten individual studies of the main royals to help him with the big portrait. Now he concentrates on how **the family of Charles IV** appear as a group.

He looks at the family arranged in front of him and moves among them, adjusting their positions. Sometimes he forgets how difficult life can be now that he is deaf. He can't hear the sound of the family's chatter and he can't hear his own voice so he can't talk to them. He has no idea if they can hear the birds or fountains he knows to be in the palace gardens.

He picks up his brush and focuses on the shadow of the wall that is cast over Prince Ferdinand. Goya doesn't know what an omen this shadow is. In just a few years the young prince will be King Ferdinand VII and he will be in hiding when the French invade Spain. Goya extends the shadow over the canvas he has painted himself working on, behind the royal group – a 54-year-old silent witness to life in the royal Spanish court.

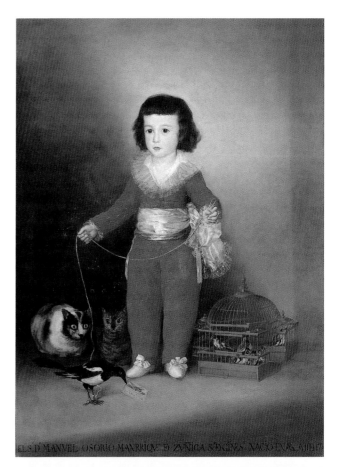

Manuel Osorio Manrique de Zuñiga (and detail)

Goya earned a good living painting portraits of wealthy Spanish people. This painting is of the third son of the Count and Countess of Altamira. He died aged only 8. Here he plays with a magpie, who is eagerly watched by cats hiding in the shadows. They are a symbol of how quickly youth or innocence can disappear.

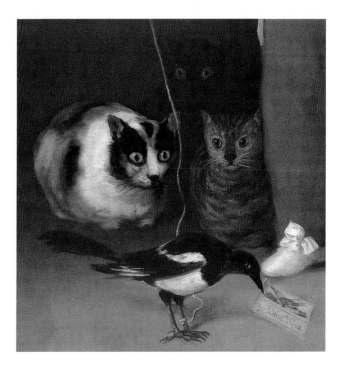

FRANCISCO DE GOYA 63

Jacques-Louis David

Jacques-Louis David (1748–1825) was a passionate supporter of the French Revolution. His paintings, influenced by his deep knowledge of classical art, told tales of sacrifice, loyalty and patriotic duty. They were used to support the cause of the Revolution.

Self-portrait, 1794

1816

Jacques-Louis David stands in front of his easel and looks at the handsome, well-dressed man sitting facing him. It is **Comte Henri-Amédé de Turenne**. The Comte, or Count, is an exiled follower of the Emperor Napoleon. This means he has had to leave his native France to live elsewhere, following the Emperor's defeat at the Battle of Waterloo. The Comte has moved to Brussels, Belgium. David is also living in Brussels, having moved there from Paris earlier in the year. Although David is making a good living painting portraits, he actually prefers to work on history paintings. But he is now 68 years old, and also in exile, so he mustn't grumble at painting a portrait or two.

For over ten years David was Napoleon's First Painter, the highest honour for an artist in France. He had admired the Emperor for his courage and determination, and had willingly painted him in heroic poses, as shown in **Napoleon Crossing the Saint Bernard Pass**. David had painted five versions of Napoleon crossing the Alps. In reality the Emperor had ridden on a mule, but he had asked David to paint him on a spirited horse to make him seem brave and daring.

Comte Henri-Amédé de Turenne

The Comte was one of Napoleon's military leaders, but following Napoleon's defeat at Waterloo and the Comte's own exile to Brussels, he had asked David to paint him out of uniform (earlier in the year David had painted him in uniform). Dressed as a civilian, the Comte wanted to distance himself from his role on the battlefield. But he is still proud of his achievements: his medals are poking out from under his collar.

Napoleon Crossing the Saint Bernard Pass

Napoleon crossed the Alps with the French army and surprised the Austrian troops who didn't expect him to make such a dangerous journey. His daring led to the French winning the Battle of Marengo. Here soldiers can be seen pushing gun carriages up the steep slopes. Napoleon sits calmly, pointing to the mountain's summit, as his horse rears up.

The Oath of the Horatii

This history painting shows three Roman brothers. In order to protect Rome, the brothers are promising their father that they will kill the sons of a rival family from another Italian town, despite the fact that the two families are in fact related. David painted this picture on a return trip to Rome in 1784.

Want to see more?

ww.artcyclopedia.com/artists/david_jacques-louis.html

www.ibiblio.org/wm/paint/auth/david

Did you know?

✳ David had a tumour in his mouth that, since childhood, affected his speech.

✳ He had over forty pupils at his studio in Paris, including Jean-Auguste-Dominique Ingres and Antoine-Jean Gros.

Just a few years before painting Napoleon, David had been heavily involved in the French Revolution. He was a passionate supporter of the Revolution, which he felt represented France's attempt to become like Ancient Rome – to be a glorious republic no longer ruled by a king but by the people. He had fallen in love with Rome when he had spent five years there after winning the prestigious Prix de Rome, awarded by the French Royal Academy, in 1774.

David now looks at the Comte's rugged face – his asymmetric eyes, bushy sideburns and hint of a beard – and contrasts it to the classical statues he sketched in Rome, with their perfect marble skin and idealized features. David filled twelve sketchbooks in Rome and has used them as reference books for his history paintings ever since. From the beginning, he didn't like the frothy, busy style of painters such as François Boucher, his cousin, and preferred to work from his sketches to create paintings that imitated classical works of art. This style was called Neo-classical. He wanted his paintings, such as **The Oath of the Horatii**, to be serious and responsible, to illustrate themes of courage, duty and sacrifice.

He studies the fine clothes of the Comte sitting in front of him – the silk lining of his top hat, his leather gloves, his black fur-lined coat. It's a long way from the portrait he did of the journalist Jean-Paul Marat during the Revolution. Marat had a skin condition and spent long hours in the bath every day to ease his symptoms. He would write in there, a turban soaked in vinegar wrapped around his itching head. David was asked to paint a portrait of **the death of Marat**, after Marat was killed in his bath by a supporter of the king. David simplified the bathroom and made Marat seem handsome in order to create a painting that made him look like a martyr.

David painted Marat's portrait because of a shared belief in the need for revolution. He is painting the portrait of the Comte de Turenne for money. Increasingly David's simple and serious history paintings are going out of fashion. His portraits, however, are still much respected and admired. He smiles at the Comte, and starts to paint the medals pinned onto his coat, under his collar.

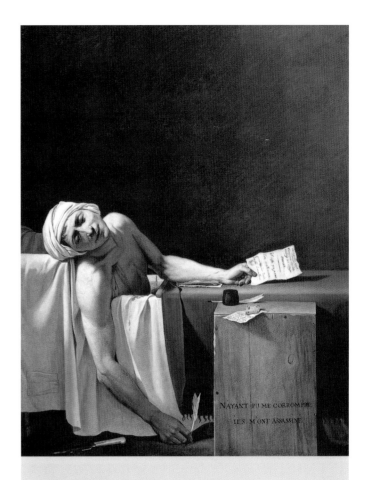

The Death of Marat

Journalist Jean-Paul Marat was killed by Charlotte Corday on 13 July 1793. Marat holds a letter from her in his hand. They were on opposite sides of the French Revolution, and she stabbed him to death in his bath. David not only painted Marat's portrait but also organized a lavish and grand funeral for him.

WHY DON'T YOU?

* Make a poster about something you believe in.

* It could be your country, or recycling, or planting trees, or saving endangered animals.

* Use a big sheet of paper and bright colours for maximum impact. You could even design your own logo....

J.M.W. TURNER

The paintings and prints of Joseph Mallord William Turner (1775–1851) reveal his passionate love of all aspects of nature, from mountains and valleys to rivers and the sea. He was compared to the greatest painters in history during his own lifetime.

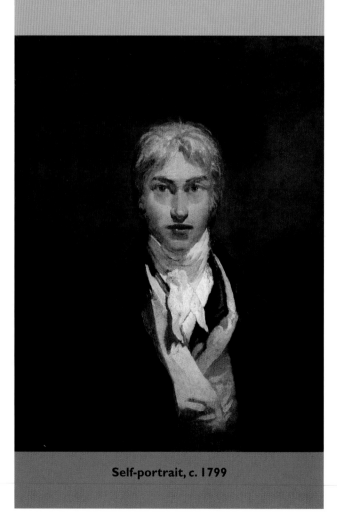

Self-portrait, c. 1799

1843

Joseph Mallord William Turner, known to his friends as William, is standing in the gallery in his house in London looking up at the ceiling. It is made of glass, like a greenhouse, and he can hear the rain pattering on it. Plates and bowls stretch across the floor, collecting water where the broken panes are leaking. Turner's visitor, a brewer who wants to buy a painting for his new home, steps carefully around the bowls. He is looking at each painting in turn, not noticing the mould growing on the gallery's red walls, the paint peeling off the early work. Turner doesn't like spending money unless absolutely necessary.

He wishes the brewer would leave so he can get on with his painting. He makes a lot of money from his watercolours and engravings which illustrate books of poetry and guides to Britain and Europe. He is often paid to tour England, recording what he sees. He keeps all his old sketchbooks neatly filed in his studio in the room next door. He wishes he could go and look at them now, to be inspired by the drawings he made earlier, such as the one of **Fountains Abbey** in Yorkshire.

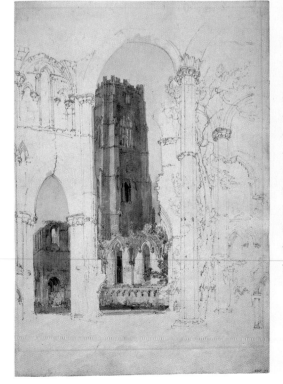

Fountains Abbey (sketch)

Turner drew this detailed sketch of Fountains Abbey during a tour of northern England. He first sketched the ruin with a pencil, and then worked on parts of it with watercolour paint. He liked to refer to the works in his sketchbooks when he was making paintings. On the tour when he made this drawing, he filled two whole sketchbooks.

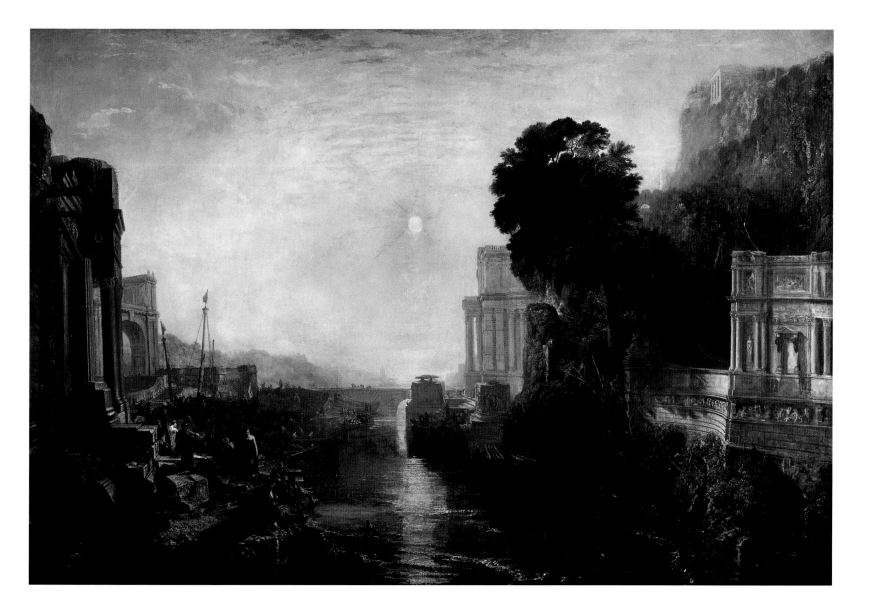

Dido Building Carthage

Turner thought this was the best painting he ever made. It is similar to the Neo-classical landscapes of the seventeenth-century painter Claude, whom Turner greatly admired. But in this Turner pays as much attention to the soft sunlight that fills the painting as to the story of Dido building the city of Carthage in Libya.

Want to see more?

www.ibiblio.org/wm/paint/auth/turner

www.artcyclopedia.com/artists/turner_
joseph_mallord_william.html

www.abcgallery.com/T/turner/turner.html

Turner has done a lot of travelling, and he loves the countryside. He now appreciates how the atmosphere – air, sunlight, fog, rain – can change how somewhere looks. He often repeatedly paints the same place to show these effects. Above all he loves the sun, painting it directly as no artist has dared to do before.

Turner's success has made him wealthy enough not to need to sell his paintings, but when he started out that wasn't the case. His father was a barber in London and Turner was born above the shop. He started out colouring in prints and copying paintings for rich collectors before entering the Royal Academy school when he was only 14 years old. He exhibited his first painting there the year after. He remembers now how, very quickly, other artists and critics were comparing him to famous painters such as Claude and Rembrandt. He had liked that. In fact he had imitated Claude when working on ambitious paintings such as **Dido Building Carthage**.

Venice: A Storm

When Turner first travelled to Italy in 1819, he fell in love with the city of Venice. He returned there in the 1830s, and again in 1840, when he worked on this dramatic watercolour. Turner's paintings of Venice – with their beautiful light and dreamy atmosphere – were very popular with critics and collectors.

Did you know?

Turner was often called Little Turner, because he was very short. Some people also thought he was a little odd.

Turner's travels have taken him around England, Holland and Italy. He is always sketching, then creating paintings when he gets home to London. His landscapes of ports, like Scarborough and **Venice**, are much in demand. Turner has always loved water, and often takes boat trips. One time, when he was a young man, he was caught in a storm as he crossed the English Channel, and the boat he was in nearly sank. As soon as he reached dry land he took out his sketchbook and stood in the wind and rain drawing the scene. He later made it into a painting, **Calais Pier**.

Just last year he had painted another dramatic picture. He had wanted to show what a storm was really like, what it felt like from within, but when he had hung **Snow Storm: Steam-Boat off a Harbour's Mouth** on the walls of the annual Royal Academy exhibition, one critic said it looked like soapsuds and whitewash. Turner was very angry. He had made the sailors of this very boat tie him to the mast so he could experience the storm directly.

Turner shakes his head. But finally the brewer is ready to leave and so the artist can enter his studio at last. He picks up one of his **sketchbooks** and a bottle of his favourite colour, chrome yellow, and then he picks up a paintbrush.

Sketchbook

Turner sketched all the time. He carefully numbered all his sketchbooks and they lined his studio. He referred to them constantly for ideas.

Calais Pier, with French Poissards Preparing for Sea: An English Packet Arriving

This is an early painting by Turner. Compare it to *Snow Storm*, painted forty years later – he treats a storm at sea quite differently. In this painting we can see sailors and passengers being blown about by the weather. Look at how the wind fills the sail of the boat in the middle of the painting, threatening to capsize it.

Snow Storm: Steam-Boat off a Harbour's Mouth Making Signals in Shallow Water, and Going by the Lead. The Author was in this Storm on the Night the Ariel left Harwich

Turner often gave his paintings long titles to explain them. In the middle of this painting is the small black shape of a steam-boat. Turner's brushstrokes shape the storm clouds and waves that swirl about the boat, giving them lots of raging energy.

WHY DON'T YOU?

Paint a picture of the weather outside. Is it sunny, or windy, or raining, or snowing?

Eugène Delacroix

Ferdinand Victor Eugène Delacroix (1798–1863) painted passionate and emotional paintings that were at odds with the traditional Neo-classical style of the day. Labelled the leader of Romanticism, he worked relentlessly, despite poor health, and completed thousands of paintings.

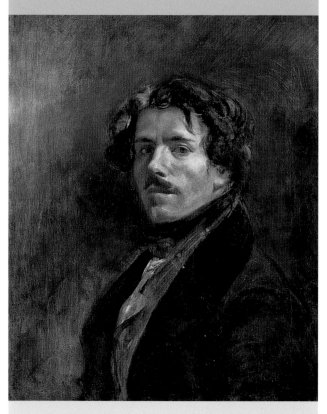

Self-Portrait in a Green Waistcoat, c. 1837

1845

ugène Delacroix is walking across the wooden floor of his large new studio in Paris, France. He is carrying a stack of sketchbooks. He has already hung dozens of his paintings on the studio walls. Several tables hold his long-handled brushes, paints and palettes, and easels display the paintings he is hoping to sell. There is a piano in the corner that he bought so his friend Frédéric Chopin can play whenever he stops by. There is also a cabinet of books by Romantic poets such as Lord Byron and Walter Scott. Delacroix's contemporaries have long called him the leader of Romanticism, but he hates the idea of being labelled in this way.

He reaches the book cabinet and opens the glass doors. There are his volumes of Shakespeare's plays and Dante's *Divine Comedy*. Dante's medieval poem about a poet's journey into hell inspired

Liberty Leading the People

This painting depicts Liberty (or Freedom) as a woman holding the French flag, known as the Tricolore, high above her. Men from Paris follow behind, clutching weapons. The government bought Delacroix's painting but didn't allow the public to see it for nearly twenty years.

Delacroix's first big painting, **The Barque of Dante**. He painted it in 1822, when he was still a student at the Ecole des Beaux-Arts, and it is full of passion and emotion. It was exhibited at the annual art exhibition, the Salon, and caused a sensation because it was so different to the dominant Neo-classical style of the day.

Delacroix went on to create many more dramatic paintings. His rousing **Liberty Leading the People** was painted in response to the July Uprising of 1830, when people rioted on the streets of Paris and forced King Charles X of France to abdicate. Delacroix had not taken part in the fighting on that day, although he had been in Paris. He was a small, thin man who was often unwell, though he used to paint until he couldn't speak from exhaustion.

The Barque of Dante

Dante, in the red cap, accompanies the cloaked poet Virgil across a lake. They are getting away from a burning city, whose skyline can be seen against the clouds. All around them dead people try to clamber on or bite the boat. The painting is dramatic and emotional, something new to art when it was painted.

want to see more?

www.ibiblio.org/wm/paint/auth/delacroix

www.artcyclopedia.com/artists/delacroix_eugene.html

The subject for this painting – the suicide of the Assyrian king Sardanapalus – was taken from a poem by Lord Byron, although Delacroix made up many things to give his painting more drama. Here, on Sardanapalus's orders, soldiers kill his girlfriends, horses and servants. Soon the king, lying on the bed, will kill himself.

Did you know?

* *Delacroix was once described as 'a volcanic crater beneath flowers', because he had a fiery temper.*

* *He kept a diary, on and off, his whole life.*

Delacroix painted many huge canvases, including **The Death of Sardanapalus**. But, while critics had liked *The Barque of Dante*, they hated his later paintings and thought they were too emotional. Luckily for Delacroix he had family connections within the government, and the government continued to buy his work.

In 1832, two years after the Paris riots, Delacroix travelled to Morocco as part of a six-month diplomatic mission to visit the Sultan. While he was there, he filled several **sketchbooks** with drawings, watercolours and notes. His trip was life-changing. He had always loved colour, and experimented with complementary colour theories, but now he fell in love with the strong colours and bright light he experienced. His visit to Morocco led him to paint many scenes taken from drawings in his sketchbooks, from horse fights and **lion hunts** to weddings and market scenes.

Right now, though, he doesn't have time to look through his sketchbooks. He carefully places them in his book cabinet and shuts the door. Soon he must start the designs for the library of the

The Lion Hunt

Delacroix loved visiting the Paris zoo and sketched animals there many times. He used his sketchbooks from Morocco to help him create scenes in which to place the animals. This dramatic painting is full of action as the lion fights for its life. Delacroix was inspired by animal hunt pictures he had seen by the Flemish painter Peter Paul Rubens.

* Start your own sketchbook. Take it with you on holiday, or to art galleries, or whenever you go on an outing.

* You could also use your sketchbook as a diary.

Sketchbook

Delacroix filled seven sketchbooks with drawings, watercolours and notes while he journeyed around Morocco. He used his notes and sketches as inspiration throughout his life, and made over a hundred paintings based on his time in Morocco.

Luxembourg Palace. For over ten years he has been kept busy with big commissions, decorating government chambers and royal palaces. He has to work with assistants to cover the vast walls and ceilings, and he completes hundreds of drawings for each project.

He takes out a box of pastels and a sheet of paper and starts to sketch, but his heart isn't in it today. He will be leaving for his cottage in the country soon, where his housekeeper, Jeanne-Marie, will look after him. He is very much looking forward to some peace and quiet.

ÉDOUARD MANET

Édouard Manet (1832–1883) painted the bars, concerts, parks and railways of contemporary Paris. He was one of the first artists to paint the modern world, and his paintings shocked the public when they were first exhibited.

Self-Portrait with a Palette, c. 1879

1884

It is a cold February day, but still the auction house is filling up quickly. It is the day of the sale of the contents of Édouard Manet's studio. Men in top hats and white gloves are entering the auction room. The artist died a year ago, but he would have fitted in well here. He inherited lots of money from his father, and enjoyed dressing well. When people met him after seeing his paintings, which many described as messy and unfinished, they were surprised. They expected Manet to be a dirty, long-haired artist working in a shabby attic studio, but he was a fashionable man who painted in a wood-panelled room filled with expensive vases.

In the auction room the sale of Manet's paintings is about to begin. The audience quietens down, concentrating as each painting is brought into the room. Two men struggle with a big painting called **A Bar at the Folies-Bergère**. It was painted by Manet just a year before he died. In it a woman is selling drinks and snacks.

A Bar at the Folies-Bergère (detail)

There were always people acting or singing on the stage at the Folies-Bergère, but often people were too busy looking at each other to notice. Here, the woman looks one way and the man looks the other. Nobody looks at the acrobat with the green shoes swinging above their heads.

WHY DON'T YOU?
Make a collage of faces. Cut them out of magazines and stick them together to make a crowd scene.

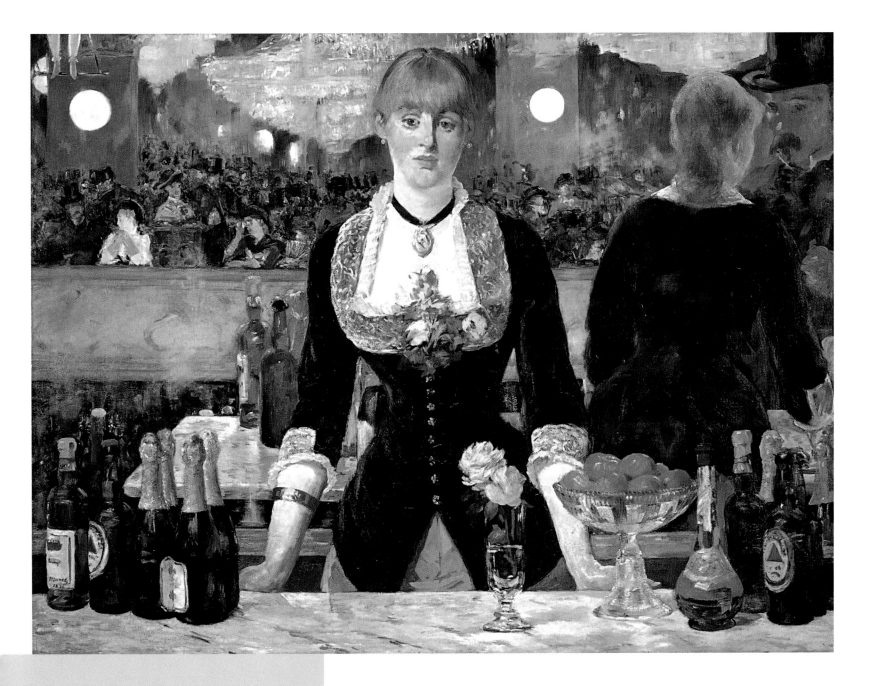

A Bar at the Folies-Bergère

Everything in the painting is a reflection, except for the bar and the barmaid Suzon. She looks out at us, but doesn't really see us. She seems a little sad, lost in her own thoughts. In the mirror, however, it seems as if she is leaning over, serving a top-hatted customer. Her reflection doesn't match the person we see. Look carefully at the bottles of champagne and beer Suzon is selling. They stand at the back of the bar, but in the mirror they have moved to the front. Manet played lots of tricks like this, making us realize that this painting is all about looking.

She is working at the Folies-Bergère, a concert hall near Manet's studio where people could drink, talk and watch singers and dancers on stage. Café-concerts like the Folies-Bergère were very popular, and rich and poor alike visited them regularly. Manet persuaded a Folies-Bergère barmaid called Suzon to stand behind a table in his studio as if it were a bar, and he recreated the atmosphere of the concert hall on his large canvas. Behind Suzon we can see a crowd of people sitting in the balcony seats of the hall. They are actually a reflection in a mirror – you can see its gold frame just behind the bar.

Manet wanted this picture to be difficult to work out. The reflections in the mirror don't match up and the people in the balcony are blurry as if they are still moving about. In 1882 – the

year before Manet died – the painting was shown at the official annual French painting exhibition called the Salon, but it didn't sell.

Because Manet was wealthy, he didn't really need to sell his paintings to survive, but he was keen for people to see them. He wanted his paintings to be the stars of the Salon, but more often than not they were refused entry. He called the Salon his battleground, for good reason.

Even when his work was accepted into the Salon, it was often criticized. After his famous painting of a naked woman, *Olympia*, was shown there in 1865, Manet complained to a friend that criticism rained down on him like hail. People were shocked by his sketchy style of painting and his modern subjects.

In 1866, however, Manet painted a picture of a young boy, and this met with more acceptance. The painting was called **The Fifer**.

The Fifer
Manet had friends in high places, and one of them organized for an Imperial Guards fifer to pose for the artist in his studio. Fifers were boys too young to fight who would have used their fife (an instrument like a flute) to send musical messages across the battlefield.

The Railroad
The subject of this painting is not the woman with the dog sleeping in her lap, or the little girl in her best dress. The subject is the railway beyond the railings. All we can see are clouds of steam coming from the engines.

Did you know?

✳ When Manet was young, he would go to the Louvre museum in Paris to copy the work of the Old Masters. He wanted to find out how the artists of the past could paint and draw so well.

✳ One of Manet's heroes was Diego Velázquez (see page 52). Manet's picture of the fifer was influenced by Velázquez's work.

Want to see more?

www.edouardmanet.com

www.abcgallery.com/M/manet/manet.html

www.artcyclopedia.com/artist/manet_edouard.html

www.artchive.com/artchive/M/manet.html

Manet's studio was just around the corner from the auction room where his paintings were now being sold, a year after his death. The studio was on a street near the Gare Saint-Lazare, Paris's busiest railway station. Manet painted the steam from the trains at the station in **The Railroad**. He often painted everyday things he saw in Paris. He painted people picnicking and sitting in cafés. He was friends with other young artists in Paris – Claude Monet (see page 80), Pierre Renoir, Berthe Morisot – though he never showed his paintings at their private 'Impressionist' exhibitions.

Back in the auction house, bidding for *A Bar at the Folies-Bergère* has risen above 5,000 Francs. It finally stops at nearly 6,000 Francs. 'Sold to Monsieur Chabrier,' declares the auctioneer, and the painting is carried from the room.

CLAUDE MONET

Claude-Oscar Monet (1840–1926) is the supreme Impressionist painter. Throughout his life he painted outdoors and focused on the changeable effects of light on the landscape. Increasingly he painted in series and is best known for his many depictions of water lilies.

Self-portrait, c. 1915–17

1914

I t is a sunny summer's morning as Monet leaves his house. He has a straw hat pulled down to shade his eyes and, although it is warm, he is wearing a tweed three-piece suit. He strokes his long, white beard as he watches men arriving to start work on the construction of his vast new studio. He has designed it so he can paint his most ambitious series of water-lily paintings yet, destined to be given to the nation.

Monet loves water. He remembers painting the light on the water when he lived at **Argenteuil**, a village on the river Seine just a few miles outside Paris in France. He had moved there as a young man with his wife Camille and son Jean. His paintings weren't selling at that time and the family had very little money to live on, but Monet continued to paint outdoors all day, every day.

After years of being rejected by the official Salon, Monet and his friends had set up an independent exhibition of their own in 1874. What a disaster that had been. All their work, particularly his **Impression: Sunrise**, had been criticized as being sketchy and

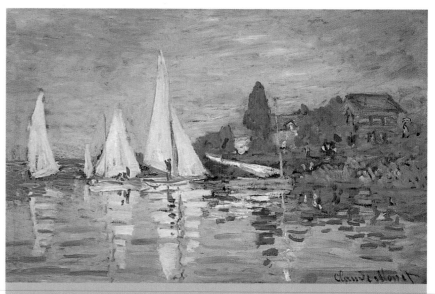

Regattas at Argenteuil

Look at the reflections of the boats and houses, distorted in the rippling water. In this early painting Monet uses unmixed colours to capture the brightness of the sunny day. His brushstrokes are applied quickly to suggest the moving river.

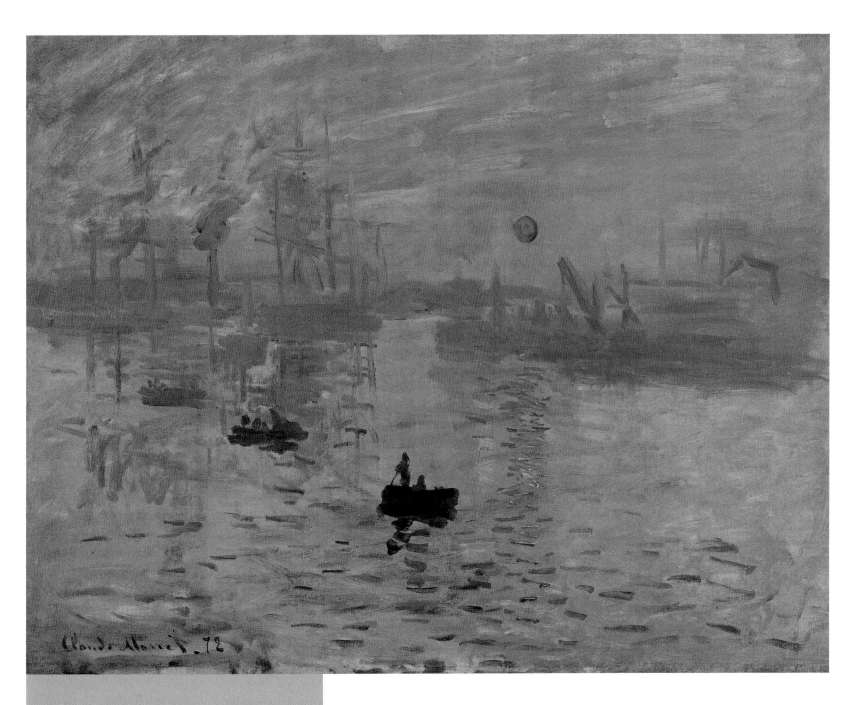

Impression: Sunrise

This work, painted in Le Havre in 1873, gave its name to the Impressionists thanks to a journalist, Louis Leroy, who reviewed the first exhibition of Monet and his friends. Leroy couldn't believe that artists were presenting works like *Impression: Sunrise*. This painting looked like an unfinished sketch to him, an 'impression' of a subject and not a work of art. He called such painters 'Impressionists', and the name stuck.

unfinished. None of the painters had sold anything. Monet, however, had been lucky to meet an art dealer in London several years previously. He had travelled to London to escape having to fight in the war between France and Prussia, and there he had met Paul Durand-Ruel. Now Durand-Ruel sold out shows of Monet's work in less than a week.

It had been a long struggle, though. In the early days it was so difficult for Monet to find buyers. His work was just too new, too different, and people could not understand it. What he was really doing was painting how quickly the light moved over objects,

The Haystacks

Monet began working in series in 1890. He painted the same subject again and again but at different times of the day. His subject matter wasn't haystacks but the light that played upon them and caused them to change colour. His stepdaughter would push his canvases around in a wheelbarrow so he could keep changing which one he worked on, depending on the light he experienced.

La Gare Saint-Lazare, Arrival of a Train

Some critics started to support Monet and his friends after the first couple of Impressionist exhibitions, and they liked this painting because it depicted modern Paris. But in reality Monet wasn't painting the engines or the new glass and steel station. He was painting the steam that billowed up into the roof.

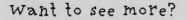

Want to see more?

http://giverny.org/monet

www.expo-monet.com

www.artofmonet.com

colouring them differently as it went, but at first glance he simply seemed to be painting **train stations** or **haystacks**. He worked outdoors and often on several canvases at once, recording the different light effects as the sun changed position.

Now, sadly, Monet is sensitive to light. He has cataracts in his eyes and they have affected his vision. He can no longer paint at lunchtime when the light is strongest, and he knows that he sees the world through a foggy haze.

He walks towards the gate at the bottom of his flower garden. He has worked on this garden since he first moved to Giverny, some 75 kilometres (40 miles) outside Paris, thirty years ago. He has planted it as if it were a giant painting and it is a riot of colour. But beyond the gate is a very different garden. It is an oasis of calm. Monet enters it and walks onto the Japanese bridge that spans the

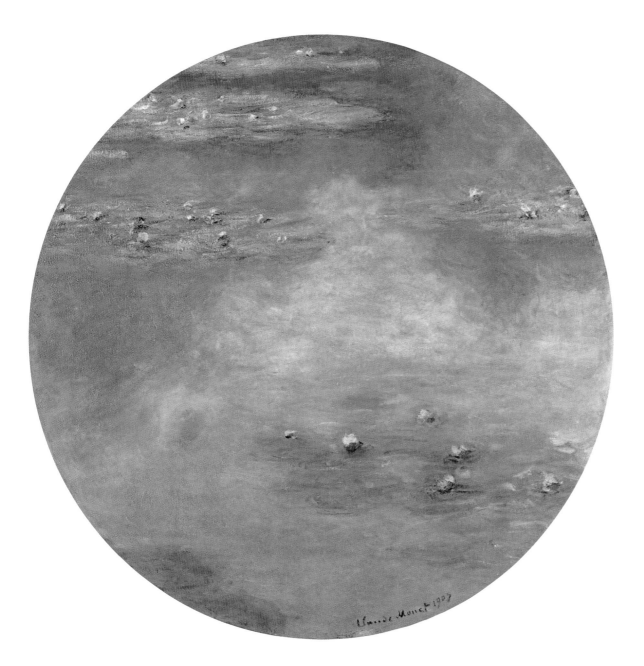

Water Lilies

Water lilies occupied Monet for the last twenty years of his life. He created hundreds of paintings of them on ever-larger canvases. They became more and more abstract as he concentrated solely on the changing light that played upon the surface of the water of his pond and the flowers that floated on top.

WHY DON'T YOU?

✳ Make a nature artwork.

✳ Paint the flowers, trees and grasses you see growing in your garden or in a local park. Or make a collage of pressed flowers and leaves.

Did you know?

✳ Monet loved water so much he once said he'd like to be buried in a buoy at sea.

✳ Many of the paintings he worked on before he had an operation to remove the cataracts from his eyes have a reddish tone. After the operation he repainted some of the colours.

large central pond. A young gardener is just clambering into a small boat that is moored at its edge. Monet employs six full-time gardeners and they keep both his gardens in perfect condition, which is just as well as this one is his only subject these days.

Monet studies the **water lilies** blooming on the dark green water, then leaves the bridge and makes his way to a large white umbrella set up on the bank by a weeping willow tree. He knows there is no time to waste. He settles himself on a high stool under the umbrella and looks at the half-finished painting on the easel in front of him. He has had to get up at dawn for three days now to try and capture the early morning light on the pond. He knows he only has half an hour at most to paint this work today. He lifts his palette and brush, and he starts to paint the light playing over the surface of the water and the floating lily pads.

VINCENT VAN GOGH

Vincent Willem Van Gogh (1853–1890) only sold one painting during his lifetime. Now his expressive bold paintings of people, landscapes and interiors are highly prized.

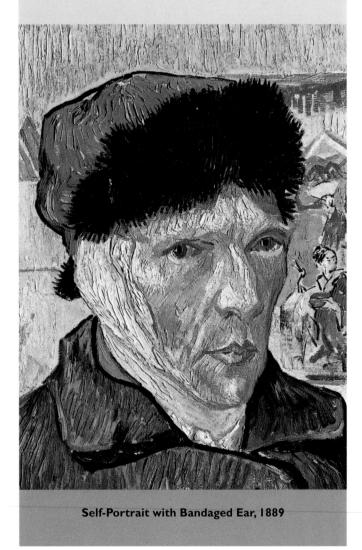

Self-Portrait with Bandaged Ear, 1889

1888

Vincent Van Gogh is lying in bed in Arles, a town in the south of France, waiting for morning. It is a cold October night, and he pulls the blanket around him. He is waiting for his friend, the artist Paul Gauguin, to arrive. Van Gogh is pale and thin, with red hair and beard. He is a nervous man who speaks quickly, and in his letters to his younger brother Theo he worries about going mad. His painting clothes – a workman's blue jacket and trousers – hang on pegs behind his bed with his straw hat. Most of the time he paints outside, and the hat keeps the sun from his eyes.

Van Gogh became a painter after working as an art dealer and preacher in London and in Holland, where he was born. His early paintings were dark and gloomy portraits of **poor peasants.** But as soon as he moved to Paris and saw other young artists' work his paintings changed. His work became brighter and he started to paint outside.

Many artists at the time chose to spend their summers by the sea, but while the artists Van Gogh had met headed to Brittany in northern France, Van Gogh went south in search of sunshine. He rented the brightly painted 'Yellow House' in Arles, and set to

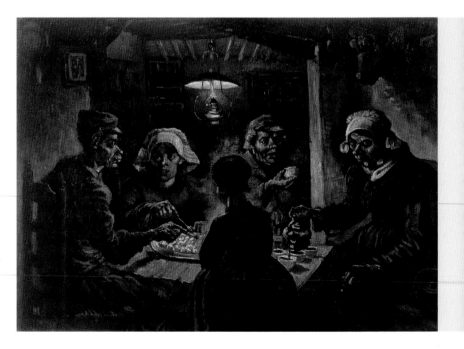

The Artist's Bedroom at Arles

In this painting there are many things in pairs – two pillows, two chairs, two portraits on the wall. It is as if Van Gogh is looking forward to there being two people in the house, working side by side.

Did you know?

* *Van Gogh wrote over 800 letters to his family and friends.*

* *While in Arles, Van Gogh and Gauguin used a coarse material called jute for their canvases. This made them apply the paint more thickly and use heavier brushstrokes.*

Five Persons at a Meal (The Potato Eaters)

This is an early painting by Van Gogh. He was keen to paint the reality of being poor. He wanted to show that the people eating potatoes in the lamplight had also dug those potatoes from the ground.

WHY DON'T YOU?
Draw a picture of your favourite food.

work, often completing a painting a day. He had still never sold a painting, and it was only thanks to his brother Theo that he survived. Theo would send him money each month, and with it Van Gogh would buy paint and food.

Van Gogh had been trying to get artists to join him in Arles all year. Gauguin eventually said yes, and now he is on the night train to Arles. Van Gogh is too excited to sleep. He had met Gauguin in Paris the year before, and when he knew Gauguin was definitely coming to stay, he painted lots of pictures to decorate the house. He painted a picture of his **bedroom,** with its big wooden bed, table and chairs, just a week before Gauguin arrived. In contrast to his messy studio downstairs, where lots of tubes of paint lay open on the floor, he tidied his bedroom so it would appear neat in the picture. In the painting it looks as if Van Gogh has drawn the outlines of the furniture in black paint, then coloured them in with bright colours, a little like a stained-glass window.

Portrait of Doctor Gachet

In 1890, after leaving the asylum where he had been staying, Van Gogh moved to a village outside Paris called Auvers. He made friends with the local doctor, who looked after him. Van Gogh thought of Doctor Gachet as a brother. Here he painted him looking sad and quiet, despite the energetic brushstrokes of the background.

Want to see more?

www.artcyclopedia.com/
artists/van_gogh_vincent.
html

www.vggallery.com

www.expo-vangogh.com

Fourteen Sunflowers in a Vase

Van Gogh was fascinated by Japanese prints he had bought in Paris, and loved the colour yellow, the Japanese colour of friendship. He painted these sunflowers – yellow flowers on a yellow table against a yellow wall – to hang in Gauguin's bedroom.

The door on the right in the painting leads downstairs to the studio. The door on the left leads through to Gauguin's bedroom, which Vincent has decorated with large paintings, including two of **sunflowers.** All Van Gogh's works are thickly painted, with broad brushstrokes.

As Van Gogh huddled in bed that night, waiting for the dawn, he couldn't have seen what lay ahead. Gauguin would only stay a few weeks. Endless arguments between them ended with Van Gogh throwing a drink over Gauguin and Gauguin catching a train back to Paris. Van Gogh was very upset, and cut off part of his own ear in anger. He would spend Christmas in hospital, and a further year in a nearby asylum being treated for epilepsy.

When Van Gogh left the asylum, a kind local man, **Doctor Gachet**, looked after him but, despite the doctor's friendship, Van Gogh killed himself soon afterwards. He was only 37 years old,

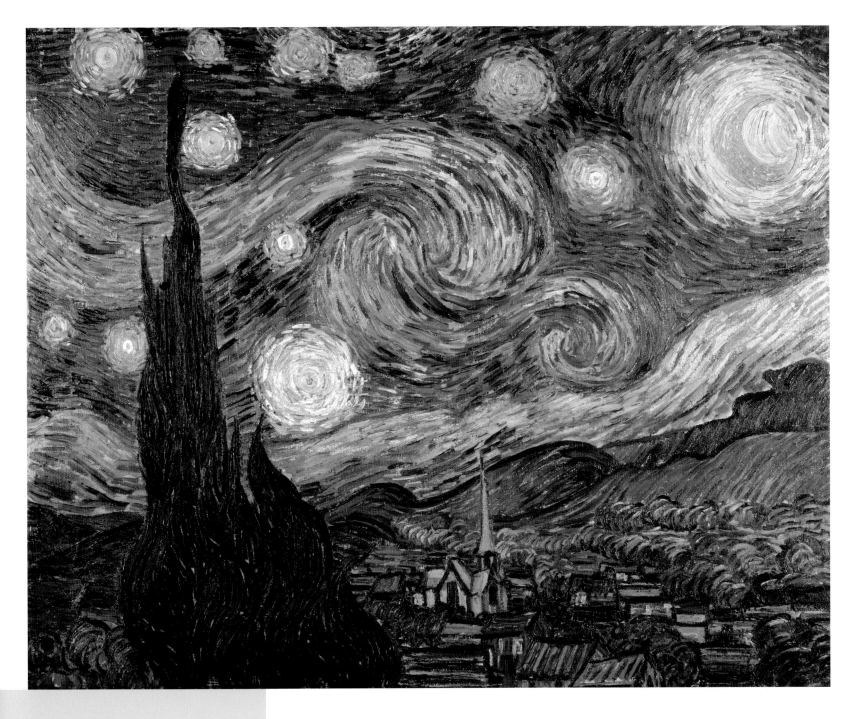

The Starry Night

This was painted while Van Gogh was living at the Saint Rémy asylum. Look at the swirling patterns in the sky, the intense light coming from the stars. The sky seems alive. When the painting was exhibited in Paris in 1889, people didn't know what to make of it, it was so different from the art they were used to seeing.

but he left behind more than two thousand paintings, drawings and sketches, including the now-famous **Starry Night**.

For now, though, Van Gogh's mind is full of plans, to persuade Gauguin to paint outdoors with him and to be inspired by the bright colours Gauguin uses. The month before, Van Gogh had painted the local all-night café in vivid colours: sunshine yellow, cherry red, pea green. Now, unbeknown to Van Gogh, Gauguin is sitting in that same café after his train arrived early. As soon as the sun rises, he will walk across the square and knock on Van Gogh's front door.

Chronologies of the Artists

Giotto

1267 He is born in the village of Colle di Vespignano, near Florence, Italy.

1277 He joins the workshop of the painter Cimabue in Florence as an apprentice.

1280 Cimabue is commissioned to paint frescoes in the Basilica of St Francis in Assisi. Giotto stays in Florence and helps in the workshop.

1285 Giotto travels to Rome and sees classical art for the first time.

1287 He travels to Assisi to work on the Basilica of St Francis. He works on it for twelve years, frequently coming back to Florence to complete other commissions, including the **Crucifix** for the church of Santa Maria Novella.

1290 He marries Ricevuta di Lapo del Pela, known as Ciuta, and they have eight children.

1300 He works in Rome for Pope Boniface VIII on frescoes for the Pope's Lateran Palace.

1303 He is commissioned to decorate the **Arena Chapel** for the Scrovegni family in Padua. He completes it in two years and returns to Florence in 1306, much in demand.

1320 He begins two fresco cycles in chapels in Santa Croce, Florence, for the Peruzzi and Bardi families.

1328 He travels to Naples to work for the King of Naples, Robert d'Anjou, for four years. He is given an annual pension before he returns to Florence.

1334 He is appointed Director of the Cathedral Works in Florence, and designs the cathedral's bell tower. It still stands and is his last known work.

1337 He dies on 8 January and is buried in the cathedral. He is the first artist ever to be given such an honour.

Leonardo da Vinci

1452 He is born on 15 April in or around Vinci, a village a day's journey from Florence, Italy.

1469 After his father shows his paintings and drawings to a friend, the successful painter Andrea del Verrocchio, Leonardo enters Verrocchio's busy studio in Florence as an apprentice.

1472 He works his way up from sweeping floors and mixing colours to painting an angel in Verrocchio's *The Baptism of Christ*. It is considered so good he becomes a master of the painter's guild of St Luke and is allowed to work as an independent artist.

1474 He paints his first known female portrait, *Ginevra de Benci*, the daughter of a friend.

1482 After moving to Milan he works for Ludovico Sforza, the heartless Duke of Milan.

1483 He is asked to paint **The Virgin of the Rocks** for the San Francesco Grande church in Milan. He finishes the painting twenty-five years later.

1484–85 He becomes interested in town planning as Milan experiences severe outbreaks of the plague.

1493 He completes an 8-metre-high (25-foot) clay model of a rearing horse for the Duke of Milan. It is destined to be cast in bronze (all 90 tons of it) but it is never completed.

1502–03 He works for Cesare Borgia as a military engineer across Italy.

1503 He begins *The Battle of Anghiari* and the **Mona Lisa** in Florence.

1506 He moves back to Milan and concentrates on his **anatomical drawing**.

1513 He moves to Rome but fails to find much work there.

1516 The King of France, Francis I, offers him a pension to live near the royal palace at Amboise, France, and Leonardo accepts.

1519 He dies in France on 2 May, aged 67.

Albrecht Dürer

1471 He is born on 21 May in Nuremberg, southern Germany, the third child of eighteen.

1483 He starts his three-year apprenticeship as a goldsmith in his father's workshop.

1486 He persuades his father to let him study painting, and enters the studio of the successful painter Michael Wolgemut as a pupil.

1490 He travels throughout Europe, working for publishers by making prints.

1494 He returns home to be married to Agnes Frey, then he travels to Italy.

1496 He returns to Nuremberg, and makes a living from printmaking.

1498 He paints his first masterpiece, *The Apocalypse of St John*.

1500 He paints himself looking like Jesus, to suggest his talent is God-given.

1505 He returns to Italy to paint **The Feast of the Rose Garlands** altarpiece for San Bartolomeo Church in Venice. He finishes it a year later.

1513 He is made an honorary citizen of the Great Council of Nuremberg.

1515 The Emperor Maximilian I grants him a salary of 100 florins for the rest of his life.

1517 He witnesses the beginning of the Reformation, a time of great change and religious unrest.

1519 Following the death of the Emperor Maximilian I, Dürer travels to Holland to ask the new emperor to continue to pay him his salary. Emperor Charles V agrees. While in Holland, Dürer becomes ill with a fever when journeying to see a beached whale.

1526 He completes *The Four Apostles*, his last great painting. He gives it to the Great Council of Nuremberg.

1528 He dies on 6 April, aged 57, from the fever he contracted nine years earlier.

Michelangelo

1475 He is born on 6 March in Caprese, not far from Florence, Italy.

1488 He starts his artistic training aged 13, as an apprentice to the painter Domenico Ghirlandaio.

1489 He joins Lorenzo de' Medici's art academy, and studies sculpture.

1496 After working in Bologna on figures for a shrine of St Dominic, he travels to Rome. He receives several commissions for sculptures, including the *Pietà* (1498–1500).

1501 He returns to Florence and carves **David**. He finishes it in 1504, and it is placed outside the Palazzo Vecchio, Florence's town hall.

1505 He travels to Rome again and starts work on a tomb for Pope Julius II.

1508 Three years later, the Pope commissions him to paint the **Sistine Chapel**, which takes him four years.

1513 The Pope dies. Michelangelo is still working on his tomb – and won't finish it till 1545, forty years after it was begun. He works for eight subsequent popes.

1524 He works in Rome and Florence, and receives many commissions from the Medici family for architectural and sculptural projects.

1527 He oversees building work in Florence as the city prepares for a battle between the new Florentine Republic and the expelled Medici family. The Medici return and Michelangelo runs away, but is later pardoned.

1534 He settles in Rome permanently.

1536 Pope Clement VII asks him to return to the Sistine Chapel and paint the back wall. **The Last Judgment** is finished in 1541.

1547 He becomes head architect of the Pope's new church, St Peter's.

1550 The first biography of Michelangelo is published, in Giorgio Vasari's *Lives of the Artists*. He is the only living artist included.

1564 He dies in Rome on 18 February, aged 88. His body is taken to Florence, where he is buried.

Raphael

1483 He is born on 6 April in Urbino, Italy.

1491 His mother dies.

1494 His father dies, and his uncle looks after him. Very little is known of his subsequent childhood, but at some point before 1500 he moves to Perugia and joins the workshop of Pietro Perugino, a highly successful painter.

1504 He moves to Florence and sees the work of Leonardo da Vinci and Michelangelo first-hand.

1505 He paints **The Ansidei Madonna** for a church in Perugia. Many of his commissions are for the city of Perugia.

1508 He moves to Rome and works for Pope Julius II, painting his private apartments in the Vatican Palace. They will occupy him and his assistants until his death.

1511 He paints **The Triumph of Galatea** for the villa of his patron Agostino Chigi on the outskirts of Rome. In the same year he collaborates with engraver Marcantonio Raimondi and starts to produce series of prints showing his Vatican paintings.

1511–12 He paints **Pope Julius II** in the year before he dies.

1514 Raphael is appointed the architect of St Peter's. This is the first of several major architectural commissions.

1515 The new Pope Leo X appoints Raphael Conservator of Roman Antiquities.

1515–16 He paints ten full-size cartoons for tapestries to hang under Michelangelo's new ceiling in the Sistine Chapel.

1520 He works on his final altarpiece, *The Transfiguration*, but it is unfinished at the time of his death and is completed by his studio. He dies on 6 April at 37 years of age. His tomb is in the Pantheon, where he asked to be buried.

Titian

1490 He is born around this time in Pieve di Cadore, a small town north of Venice, Italy. No one knows the date for sure, as in old age Titian liked to change the year to make himself seem even older.

1500 Around this time he travels to Venice with his brother Francesco to stay with their uncle and train as a painter. He joins Gentile Bellini's studio, later moving to study with Gentile's brother, Giovanni Bellini.

1513 Pope Leo X asks Titian to visit Rome and work alongside Raphael and Michelangelo, but Titian refuses. He doesn't like leaving Venice and he already has lots of patrons.

1516 Giovanni Bellini dies and Titian is appointed the official painter of Venice. His first major public commission is *The Assumption of the Virgin* altarpiece for the church of Santa Maria Gloriosa dei Frari. He also starts working for Alfonso d'Este, the Duke of Ferrara.

1523 He completes **Bacchus and Ariadne** for the Duke of Ferrara.

1529 Emperor Charles V becomes his biggest patron.

1530 Titian's wife Cornelia dies. In 1531 he moves with his children and his sister Orsola to a big house.

1532 Emperor Charles V knights Titian.

1545 He finally journeys to Rome at the invitation of Pope Paul III, seeking a job for his son Pomponio who has become a priest. His other son Orazio works with him in the studio, and his daughter Lavinia sometimes models for him.

1548 He travels to Augsburg, Germany, and paints **Charles V on Horseback**, among other works. Charles's son Philip II, the future King of Spain, will become his next major patron.

1576 Titian dies on 27 August during an outbreak of the plague in Venice. He is buried in the church of Santa Maria Gloriosa dei Frari.

Hans Holbein the Younger

1497 He is born around this time in Augsburg, Germany. His father, Hans Holbein the Elder, is a portrait artist and Holbein the Younger initially trains with him.

1514 He moves to Basel and becomes an apprentice in the studio of painter Hans Herbster.

1518 He travels to Italy and is impressed by the work of Leonardo da Vinci and Andrea Mantegna.

1519 He marries Elsbeth Binsenstock. They have four children.

1523 He paints three portraits of the scholar Erasmus.

1526 He travels to England to find work. He stays with **Sir Thomas More** and paints his portrait in 1527.

1528 He returns to Basel to ensure he doesn't lose his right to work in the city, but there is little work there.

1532 He goes back to live in London. His wife and children stay in Basel.

1533 He paints **The Ambassadors**.

1534 King Henry VIII appoints himself Supreme Head of the Church. Those who oppose the appointment, including Sir Thomas More, are imprisoned and killed. Holbein paints Thomas Cromwell, Henry VIII's secretary, the man responsible for imprisoning More.

1537 Holbein is appointed the King's painter. He receives £30 ($60) a year for a range of work including paintings, book illustrations and designs for precious objects and clothes. He also travels abroad to paint portraits of possible wives for Henry VIII.

1538 He visits Basel. The city council tries to persuade him to stay, but he returns to London.

1541 He is accepted as an official resident of England and is allowed to open a workshop and use assistants. He has probably been doing this secretly for years, as he is much in demand.

1543 He dies of the plague as it sweeps through London.

El Greco

1541 He is born in Candia (present-day Heraklion) on the island of Crete, part of the Venetian Republic.

1566 By this date he is working as a master icon painter in Crete.

1567 He moves to Venice, Italy, where around 4,000 Greeks live and have their own craft guild and church. He works in Titian's studio for a time and is influenced by him and other artists including Tintoretto and Paolo Veronese.

1570 He moves to Rome, where he admires the work of Mannerist artists such as Agnolo Bronzino and Jacopo Pontormo, who exaggerate their figures and dramatize their works. He also admires the late work of Michelangelo, such as *The Last Judgment* in the Sistine Chapel.

1577 He moves to Toledo in Spain. His first commission is **The Assumption of the Virgin** altarpiece for the church of Santo Domingo el Antiguo.

1578 He and Jeronima de las Cuevas have a son, Jorge Manuel. Jorge becomes a painter and architect, and works with his father from 1594.

1580 El Greco paints *The Martyrdom of St Maurice* for King Philip II's new monastery, the Escorial, but Philip doesn't like it. Although he pays for it, the painting is never hung there.

1585 El Greco rents a large apartment in the Villena Palace.

1586 He is commissioned to paint **The Burial of Count Orgaz**.

1595 Over the next decade he paints several major altarpieces for Spanish churches.

1614 He dies in Toledo on 7 April after a long illness. He is buried in a vault in the church of Santo Domingo el Antiguo. His painting **The Adoration of the Shepherds** hangs above his tomb. But his son fails to finish works that he has promised as payment for the vault, and so El Greco's body is moved to a nearby monastery, San Torcuato.

CARAVAGGIO

1571 He is born near the Italian village of Caravaggio, after which he names himself when he is 20.

1584 He moves to Milan and is an apprentice for four years in the workshop of Simone Peterzano.

1590 When his mother dies, he inherits some land, which he sells. He uses the money to move to Rome in 1592 but ends up living in poverty. He never returns to the north of Italy again.

1593 He works for Giuseppe Cesari, helping him with the frescoes for the ceiling of the Contarelli Chapel in the church of San Luigi dei Francesi.

1594 He spends much of the year in hospital after being kicked by a horse.

1595 He lives in Cardinal Francesco Del Monte's palace after Del Monte buys his painting **The Cardsharps**.

1599 He receives his first major commission and finishes **The Calling of St Matthew** and *The Martyrdom of St Matthew* for the Contarelli Chapel the following year.

1600 He signs a contract to paint **The Conversion of St Paul** and *The Crucifixion of St Peter* for the church of Santa Maria del Popolo.

1602 He is commissioned to paint **The Inspiration of St Matthew** altarpiece for the Contarelli Chapel.

1606 He is seriously wounded in a fight, but his opponent dies. He hides for three days then flees to Naples.

1607 He hopes his influential friends and patrons can secure him a pardon from the Pope. While he waits, he travels to Malta and works for the Maltese Knights.

1608 He becomes a Knight of the Maltese Order in July, but by Christmas he has been stripped of his honours following an argument with a fellow knight. He is imprisoned but escapes and travels to Sicily.

1610 He dies of a fever as he journeys back to Rome, where the Pope is about to pardon him.

ARTEMISIA GENTILESCHI

1593 She is born on 8 July in Rome, Italy, the eldest of five children. When she is 12, her mother Prudentia dies. Her father Orazio is a successful painter, and Artemisia trains in his workshop.

1610 She paints her first known works, **Madonna and Child** and *Susanna and the Elders*, aged 18.

1611 Her father employs the painter Agostino Tassi to tutor her privately but he attacks her and there follows a seven-month court trial.

1613 She marries the painter Pierantonio Stiattesi and moves to his home town of Florence. She has four children but only one, Prudenzia, survives to adulthood.

1617 She receives a commission from Michelangelo's nephew, who is building the Casa Buonarroti in Florence. She paints *Allegory of the Inclination* on the salon ceiling. She is very successful in Florence, and paints for the ruling Medici family.

1620 She returns to Rome with Prudenzia but without her husband.

1627 Around this date she moves to Venice in search of bigger commissions.

1630 She settles in Naples where she is well known and receives many commissions.

1638 King Charles I invites her to his court in London and she travels there to help her father complete the ceiling for Queen Henrietta Maria's house in Greenwich. The King collects art avidly and buys her **Self-Portrait as the Allegory of Painting**.

1639 Her father dies suddenly.

1642 She leaves England and returns to Europe.

1649 By this date she is back working in Naples. She has an assistant, Onofrio Palumbo, and continues to accept commissions.

1656 She dies around this time, as the plague sweeps through Naples.

GIAN LORENZO BERNINI

1598 He is born on 7 December in Naples, Italy, but moves to Rome in 1606, where he lives his whole life.

1619 He carves *Aeneas, Anchises and Ascanius Fleeing Troy*, the first work of many for Cardinal Scipione Borghese.

1623 Bernini's friend Cardinal Matteo Barberini becomes Pope Urban VIII. For over twenty years Bernini works almost solely for him, and is soon in charge of his artistic programme, including the decoration of St Peter's.

1624 He finishes **David** for Cardinal Borghese, his last private commission for some time. The Pope persuades him to study painting, which he does for two years. Sadly most of his more than 150 paintings are now lost.

1632 He carves a portrait bust of **Cardinal Scipione Borghese** the year before Borghese dies.

1633 He completes a vast metal canopy, called the Baldacchino, for St Peter's. It marks the saint's grave.

1639 He marries Caterina Tezio after the Pope urges him to have children. He goes on to have eleven in total.

1644 The new Pope, Innocent X, favours other artists/architects, but Bernini is still in demand elsewhere.

1645 He begins work in the Cornaro Chapel in Santa Maria della Vittoria, Rome. His **Ecstasy of St Teresa** takes seven years to finish.

1648 He starts work on **Four Rivers Fountain** and, with many assistants, completes it in 1651.

1650s He concentrates more and more on architectural projects. In 1658 his design for the church of Sant'Andrea al Quirinale is built.

1665 King Louis XIV of France finally persuades him to go there. He prepares sketches for the façades of the Louvre, but they are never built.

1673–74 He completes his last major work, the altar in the Cappella del Santissimo Sacramento, St Peter's.

1680 He dies on 28 November, aged 81.

DIEGO VELÁZQUEZ

1599 He is born in Seville, Spain, and is baptized on 6 June.

1610 Aged 11 he starts a six-year apprenticeship with the painter Francisco Pacheco.

1617 He qualifies as a painter in Seville.

1618 He marries Juana Pacheco, the daughter of the painter he studied with. Velázquez is 18; Juana is 15. They have two daughters in 1619 and 1621.

1622 Velázquez visits Madrid to try and persuade King Philip IV of Spain to be painted by him, but he doesn't succeed.

1623 The following year he is asked to journey to Madrid again and paint the King. He is immediately made a painter in the King's court and moves his family to Madrid. They never leave.

1628 He is promoted to Chief Court Painter.

1629–31 He travels to Italy to study the work of Italian painters such as Michelangelo and Titian. While he is away the King refuses to let anyone paint him or his family, even his newborn son.

1648 Velázquez travels to Italy again, this time as an ambassador for the King to buy paintings for his palace.

1652 He is appointed the King's Chamberlain, the highest position at court.

1659 He finally becomes a Knight of the Order of Santiago. Their emblem is a red cross, and the King has it painted onto Velázquez's chest in the painting **Las Meninas** three years after Velázquez has finished the painting.

1660 Velázquez falls ill with a fever. The King visits his bedside, but he dies on 6 August, aged 61. The King dies five years later.

REMBRANDT

1606 He is born on 15 July in Leiden, the second largest city in Holland after Amsterdam.

1620 He studies at Leiden University, but leaves after a few months to become an apprentice with artists in Leiden and Amsterdam for four years.

1625 He establishes his own studio in Leiden and quickly becomes successful as a portrait painter.

1631 He moves to Amsterdam, where he shares a house with Hendrick Uylenburgh, an art dealer who arranges some major portrait commissions for Rembrandt.

1634 He marries Hendrick's cousin, Saskia van Uylenburgh.

1639 Rembrandt and Saskia move to a big house (now the Rembrandt House Museum in Amsterdam).

1642 He finishes **The Night Watch** a few weeks before Saskia dies of tuberculosis. His son Titus is less than a year old. His previous three children all died in infancy.

1645 Hendrickje Stoffels joins Rembrandt's household.

1654 Rembrandt and Hendrickje have a daughter, Cornelia.

1656 Rembrandt is declared bankrupt. In the following two years he has to sell his art collection and his house.

1660 He moves to a poorer part of Amsterdam with Hendrickje, Titus and Cornelia.

1663 Hendrickje dies.

1668 Titus dies.

1669 Rembrandt dies in Amsterdam on 4 October, aged 63. He is buried in an unmarked grave in the Westerkerk, a local church.

FRANCISCO DE GOYA

1746 He is born on 30 March in the Spanish village of Fuendetodos, but his family soon moves to Zaragoza.

1760 He starts an apprenticeship with the leading local artist José Luzán, and also meets the painter Francisco Bayeu at this time.

1764 He moves to Madrid and joins Francisco and Ramón Bayeu's new studio. In 1773, he marries the painters' sister, Josefa Bayeu.

1770 He visits Italy after two failures to have work accepted for the new Madrid Academy of Art exhibition.

1774 Painter Anton Raphael Mengs asks him to help design tapestries for King Charles III's royal palaces.

1780 He is finally elected a member of the Madrid Academy of Art. He becomes Deputy Director of Painting there five years later.

1786 He is appointed Painter to Charles III. Three years later, under new king Charles IV, he is promoted to Court Painter.

1792–93 He is taken ill and becomes permanently deaf.

1795 After the death of Francisco Bayeu, he becomes Director of Painting at the Madrid Academy of Art.

1799 He is appointed First Painter to Charles IV. The same year he publishes **Los Caprichos**, his first print series.

1808 He witnesses many atrocities when France declares war on Spain. In 1814 he paints works such as **The Third of May 1808** to confirm his loyalty to new king Ferdinand VII (he had also painted for the French when they were temporarily in power).

1815 By this date Goya paints almost exclusively for himself.

1820 He spends three years painting gloomy works – the Black Paintings – on the walls of his new house.

1823 Life in Spain has become difficult and Goya leaves for France.

1828 He dies in Bordeaux on 16 April, aged 82.

JACQUES-LOUIS DAVID

1748 He is born on 30 August in Paris, France.

1757 His father, a wealthy ironmonger, is killed in a duel. David is then brought up by two uncles, both of whom are architects. He is expected to follow in their footsteps, but he convinces his mother that he wants to be an artist.

1766 He starts his apprenticeship with the Neo-classical painter Joseph Marie Vien.

1771 He submits his first painting to the Academy, and expects to be awarded the Prix de Rome. He doesn't win.

1774 His painting *Antiochius and Stratonice* wins the Prix de Rome. It is the fourth time he has entered. In 1772, when he didn't win for the second time, he tried to kill himself through starvation.

1775 The Prix de Rome allows him to travel to Rome and study at the French Academy there. Joseph Marie Vien becomes Director. David stays for five years, sketching ancient sculptures and buildings.

1782 He marries Charlotte Pécoul in Paris, and they have four children.

1784 He exhibits **The Oath of the Horatii** at the French Royal Academy. By now he is seen as the most influential painter in France.

1789 The French Revolution begins. David becomes heavily involved and is imprisoned for six months in 1794.

1799 Napoleon sweeps to power in France, and in 1804 makes David his First Painter, a great honour.

1816 After Napoleon is defeated at the Battle of Waterloo in 1815, many of his supporters go into exile. David moves to Brussels, as the monarchy is restored in France.

1825 He dies in Brussels on 29 December and is buried at the Church of St Gudule after French authorities refuse to allow his body to be brought back to Paris.

J.M.W. TURNER

1775 He is born on 23 April above his father's barber's shop in Covent Garden, London, England.

1789 He enters the Royal Academy school, exhibiting his first watercolour painting the following year.

1791 He travels to Bristol, aged 16, and sketches the surrounding countryside. He continues to travel and sketch his entire life.

1793 He is awarded the Great Silver Pallet for Landscape Drawing at the Royal Academy Exhibition. It is the only prize he ever receives.

1796 He exhibits his first oil painting, *Fishermen at Sea*. It sells for £10 ($20).

1799 He is made an Associate Artist of the Royal Academy, the youngest artist to achieve this.

1802 He is made a Royal Academician at the age of 26. The same year he journeys for the first time across the English Channel and as far as the Alps.

1804 He builds his own gallery at his house on Harley Street, and exhibits his paintings there and in the Royal Academy exhibition, held every year.

1807 He is appointed Professor of Perspective at the Royal Academy, but doesn't give his first lecture until 1811.

1815 He exhibits **Dido Building Carthage** at the Royal Academy.

1819 He travels to Italy. He loves Venice, and also spends time in Rome.

1822 He opens his new gallery at his house in Queen Anne Street.

1828 He visits Rome again.

1829 His father dies, and he is very sad. They had lived together for many years, and his father had been his biggest supporter as well as his assistant.

1842 He paints **Snow Storm: Steam-Boat off a Harbour's Mouth**, claiming to have experienced the storm first-hand.

1851 He dies on 19 December.

EUGÈNE DELACROIX

1798 He is born on 26 April in a suburb of Paris, France, the youngest of four children by fourteen years.

1800 His family moves to Bordeaux. (It is thought that Eugène's real father was not in fact Charles Delacroix, but the senior diplomat Talleyrand. This would explain why the government supported Eugène throughout his career.)

1805 Charles Delacroix dies and Eugène moves back to Paris.

1814 His mother dies and he moves in with his sister. A year later he joins the studio of Pierre-Narcisse Guérin.

1816 He joins the Ecole des Beaux-Arts, the leading art school in Paris.

1818 He poses for Théodore Géricault's *The Raft of the Medusa* – a painting he will greatly admire.

1822 He exhibits his first major painting, **The Barque of Dante**, at the Paris Salon. It is a huge success. Two years later he exhibits *The Massacre of Chios*. It is described as 'the massacre of painting'.

1825 He visits England after seeing John Constable's paintings in 1824.

1827 He exhibits **The Death of Sardanapalus** at the Salon. It is condemned for being over-the-top.

1830 He paints **Liberty Leading the People** to celebrate the abdication of King Charles X.

1832 He travels to Morocco.

1833 He receives his first big state commission, to paint the Chamber of Deputies at the Bourbon Palace.

1834 Jeanne-Marie le Guillon becomes his housekeeper and guards him jealously.

1849 He begins work on frescoes in the church of Saint-Sulpice, Paris.

1857 He is finally elected to the Académie des Beaux-Arts and moves to a new studio (now the Eugène Delacroix museum).

1863 He dies in Paris and is buried in Père Lachaise cemetery.

ÉDOUARD MANET

1832 He is born on 29 January in Paris, France, the eldest of three boys.

1848 He wants to be an artist, but his father says no. He leaves school and joins the Merchant Marines, but fails his entrance exam twice.

1850 His father finally allows him to train as an artist, and he enters the studio of Thomas Couture in Paris.

1856 He leaves Couture's studio and travels extensively around Europe, looking at paintings by great artists.

1860 He returns to Paris and sets up his own studio.

1862 His father dies, and he inherits lots of money. It is the first year his works are accepted into the Salon, the official annual exhibition.

1863 Many paintings are refused entry to the Salon, including Manet's, and so the Salon des Refusés (an exhibition of rejected work) is held. Manet's painting *Le déjeuner sur l'herbe* attracts attention. He also holds a private exhibition of his work. In October he gets married to Suzanne Leenhoff.

1865 He exhibits *Olympia* at the Salon to much criticism.

1867 He holds his second private exhibition to coincide with the World Fair held in Paris. He exhibits fifty paintings, including **The Fifer**.

1870–71 He joins the National Guard when France declares war on Prussia. He defends Paris, sleeping on straw and often going hungry.

1874 He exhibits **The Railroad** at the Salon.

1881 He is awarded a second-class medal at the Salon. He has been painting his whole life to try and obtain a Salon medal.

1882 He exhibits **A Bar at the Folies-Bergère** at the Salon. It is the last year he enters.

1883 He dies on 30 April, aged 51.

CLAUDE MONET

1840 He is born on 14 November in Paris. His family call him Oscar.

1845 He moves with his family to Le Havre in northwest France.

1858 Landscape painter Eugène Boudin sees his paintings and encourages him to paint outside.

1859 He moves to Paris and studies at the Atelier Suisse. Monet's father doesn't approve of this laidback school and cuts off his allowance.

1861–62 He spends time in Algeria in the army. When he returns home ill with anaemia, his family pay for him to be released from the army early.

1863 His father agrees to fund him if he studies with a reputable painter, so Monet enters the studio of Charles Gleyre in Paris. When the studio closes a year later, Monet's father ends his allowance again.

1867 Monet has a son, Jean, with his girlfriend Camille. They are very poor. They marry three years later.

1870 To escape having to fight in the Franco-Prussian war, Monet flees to London, where he meets Paul Durand-Ruel – his first successful art dealer.

1871 He moves back to France.

1874 Monet and about thirty other artists hold the first Impressionist exhibition. It receives terrible reviews and is a financial failure.

1876 The second Impressionist exhibition is held.

1879 Monet's wife Camille dies.

1883 He rents a house in Giverny, and in 1890, once his paintings have really started to sell, he buys it.

1891 His first series paintings, **The Haystacks**, sell out in three days.

1892 He marries his second wife, Alice Hoschedé, who dies in 1911.

1914 He builds a large studio to house a series of 'water lily' paintings.

1926 He dies in Giverny on 5 December, aged 86, and is buried at the local village church.

VINCENT VAN GOGH

1853 He is born on 30 March in Groot-Zundert, a small village in Holland. His father is a local pastor with the church.

1869 He leaves school at 16 and is given a job by his Uncle Cent, a successful art dealer.

1876 After a stint in England working for his uncle, Van Gogh loses his job. He returns to England as a preacher.

1877 Back in Holland he starts to train formally with the church, but gives up after a year. He moves to a mining area to preach instead and is shocked by the poverty. He gives away his clothes to the poor.

1880 He decides to become an artist, and moves back home. In 1885 he paints his first important work, **The Potato Eaters**.

1885 He moves to Antwerp in Belgium. He never returns to his native Holland again.

1886 He moves to Paris, France, and lives with his younger brother Theo, who is an art dealer.

1888 He moves to the Yellow House in Arles, southern France. Paul Gauguin joins him there in October–December that year.

1889 After some time in hospital Van Gogh asks to be admitted to the Saint Rémy asylum nearby. In one year there he finishes over two hundred paintings.

1890 Theo sells Van Gogh's first painting, *The Red Vineyard*. Van Gogh moves to Auvers, a village outside Paris. But he shoots himself in the chest and dies two days later, on 29 July, aged 37.

MAJOR COLLECTIONS OF THE ARTISTS' WORKS

GIOTTO
The Arena Chapel (also called the Scrovegni Chapel), Padua, Italy: www.cappelladegliscrovegni.it/eng/info_e.htm
Basilica of San Francesco, Assisi, Italy: www.assisionline.com
Uffizi Gallery, Florence, Italy: www.uffizi.com

LEONARDO DA VINCI
Louvre, Paris, France: www.louvre.fr
Uffizi Gallery, Florence, Italy: www.uffizi.com

MICHELANGELO
St Peter's Basilica, Rome, Italy (architecture and sculpture): www.saintpetersbasilica.org
British Museum, London, England (drawings): www.thebritishmuseum.ac.uk
Casa Buonarroti, Florence, Italy (early work and family history): www.casabuonarroti.it

ALBRECHT DÜRER
Albertina, Vienna, Austria: www.albertina.at
Kunsthistorisches Museum, Vienna, Austria: www.khm.at
Alte Pinakothek, Munich, Germany: www.pinakothek.de

RAPHAEL
Vatican, Rome, Italy: www.vatican.va
Galleria Palatina, Florence, Italy: www.polomuseale.firenze.it/english/musei/palatina

TITIAN
National Gallery, London, England: www.nationalgallery.org.uk
Museo del Prado, Madrid, Spain: http://museoprado.mcu.es

HANS HOLBEIN THE YOUNGER
National Gallery, London, England: www.nationalgallery.org.uk
Louvre, Paris, France: www.louvre.fr
The Royal Collection, Royal Library, Windsor, England (many of Holbein's drawings are here and, though they are not on permanent display, they can be seen on the eGallery): www.royalcollection.org.uk
British Museum, London, England (more drawings): www.thebritishmuseum.ac.uk
Kunstmuseum Basel, Basel, Switzerland (more drawings in the Department of Prints and Drawings): www.kunstmuseumbasel.ch/en

EL GRECO
Casa-Museo de El Greco, Toledo, Spain (El Greco museum, near the location of his apartment in Villena Palace): for information see www.spain.info
Santo Domingo el Antiguo, Toledo, Spain (El Greco's burial place, and site of his first major Toledo altarpiece, *The Assumption of the Virgin*): for information see www.sacred-destinations.com/spain/toledo-santo-domingo.htm
Museo del Prado, Madrid, Spain: http://museoprado.mcu.es

CARAVAGGIO
Borghese Gallery, Rome, Italy: www.galleriaborghese.it
Contarelli Chapel, San Luigi dei Francesi, Rome, Italy (three paintings in their original home showing the life of St Matthew)
Cerasi Chapel, Santa Maria del Popolo, Rome, Italy (two paintings in their original home showing the conversion of St Paul and the crucifixion of St Peter)

ARTEMISIA GENTILESCHI
Museo di Capodimonte, Naples, Italy: http://capodimonte.spmn.remuna.org
Galleria Palatina, Florence, Italy: www.polomuseale.firenze.it/english/musei/palatina
Galleria Spada, Rome, Italy: www.galleriaborghese.it/spada/en/einfo.htm

GIAN LORENZO BERNINI
St Peter's Basilica, Rome, Italy: www.saintpetersbasilica.org
Museo Sacro, Vatican Museums, Rome, Italy: http://mv.vatican.va
Borghese Gallery, Rome, Italy: www.galleriaborghese.it

DIEGO VELÁZQUEZ
Museo del Prado, Madrid, Spain: http://museoprado.mcu.es
National Gallery, London, England: www.nationalgallery.org.uk

REMBRANDT
Rijksmuseum, Amsterdam, Netherlands: www.rijksmuseum.nl
Rembrandt House Museum, Amsterdam, Netherlands: www.rembrandthuis.nl

FRANCISCO DE GOYA
Museo del Prado, Madrid, Spain (paintings): http://museoprado.mcu.es
British Museum, London, England (prints): www.thebritishmuseum.ac.uk

JACQUES-LOUIS DAVID
Louvre, Paris, France: www.louvre.fr
Royal Museums of Fine Arts, Brussels, Belgium: www.fine-arts-museum.be

J.M.W. TURNER
Tate Britain, London, England: www.tate.org.uk
National Gallery, London, England: www.nationalgallery.org.uk
British Museum, London, England (watercolours and drawings): www.thebritishmuseum.ac.uk

EUGÈNE DELACROIX
Musée National Eugène Delacroix, Paris, France (Delacroix's old studio): www.musee-delacroix.fr
Louvre, Paris, France (most of his major paintings): www.louvre.fr
The church of Saint Sulpice, Paris, France (frescoes in the Chapel of the Angels): www.paroisse-saint-sulpice-paris.org

ÉDOUARD MANET
Musée d'Orsay, Paris, France: www.musee-orsay.fr
The Metropolitan Museum of Art, New York, USA: www.metmuseum.org

CLAUDE MONET
Monet's house at Giverny, France, is open to the public: www.fondation-monet.com
Musée d'Orsay, Paris, France: www.musee-orsay.fr
Musée Marmottan Monet, Paris, France: www.marmottan.com
Musée de l'Orangerie, Paris, France (Monet's grand cycle of water lily paintings): www.musee-orangerie.fr

VINCENT VAN GOGH
Van Gogh Museum, Amsterdam, Netherlands: www.vangoghmuseum.nl
The Kröller Müller Museum, Otterlo, Netherlands: www.kmm.nl
The Metropolitan Museum of Art, New York, USA: www.metmuseum.org.

GLOSSARY

altarpiece a painting made to hang above, or stand upon, the altar of a church.

auction a sale of works of art in which each work is sold to the highest bidder.

burin a pointed steel rod used by printmakers to engrave drawings into metal plates.

canvas a cloth stretched over a wooden frame on which artists paint.

cartoon a full-size drawing that artists use to transfer their designs for a large fresco, painting or tapestry.

carve, to carve to cut stone or wood to make an artwork.

chisel a metal tool struck by a hammer to chip pieces off stone or wood to make a sculpture.

circa (c.) approximately; as in, 'the painting dates from c. 1700', i.e. 'the painting dates from approximately 1700'.

classical the era, and style of art, of the Ancient Greeks and Romans.

commission an order for a specific work of art to be produced.

complementary colours when certain colours are placed next to each other, they cause each other to appear brighter: green is the complement of red, purple of yellow and orange of blue.

composition the arrangement of the parts of a picture.

critic a person who comments on a work of art when it is exhibited.

cycle a series of paintings telling the story of a person or an event.

easel a wooden structure used by artists to hold a canvas or panel steady and at an angle while they paint on it.

engraving a kind of print made by cutting a design into metal or wood. Ink is then brushed over the design so that it lies in the hollows. The design can then be printed onto paper.

etching a kind of print that involves covering a metal plate in a protective layer such as wax. The design is scratched into the layer and the plate dipped in acid. The acid eats into the metal plate in the shape of the design. The plate can then be covered with ink and printed like an engraving.

exhibition a display of paintings or sculptures either by one artist or by a group. An exhibition is open to the public and normally held over a few weeks or months.

façade a decorative front to a building, often added after the original structure has been completed.

fresco a wall-painting made by mixing powdered colour with water, which is then painted onto wet plaster. When the plaster dries, the painting becomes a permanent part of the wall.

history painting a painting that tells a story, usually a scene from history, mythology or the Bible.

icon a painting of a holy or important figure on a wooden panel painted in a symbolic, not realistic, way.

Impressionism a term invented by the critic Louis Leroy, and first applied as an insult to a big group of painters who exhibited together in eight independent exhibitions in Paris from 1874 to 1886. Impressionists aimed to capture the changeable light and atmosphere as it affected objects, rather than paint in the traditional slick academic style of the day.

life-size a figure or object painted the size it is in real life.

miniature a very small painting or drawing. Portraits of people in miniature were often designed to be carried around.

mosaic a form of decoration made from small square tiles of glass or stone arranged in patterns. Mosaic was used to decorate churches before frescoes and paintings became popular.

mythology a collection of stories about classical gods and goddesses that are over 2,000 years old.

Neo-classical a style of art that copied the art of the Ancient Greeks and Romans. It spanned painting, sculpture and architecture.

oil paint a form of paint made by mixing powdered colour with oil such as linseed oil. It was first used by artists around 1500.

painting a flat artwork on a canvas, panel or wall completed using paint.

panel a piece of wood specially prepared for an artist to paint on.

patron a person who supports an artist by commissioning work from them.

pigment powdered colour. In the past all colours were natural and could be made from stone, metal or even blood. Now most are synthetic, i.e. manmade.

plinth a base underneath a statue or sculpture.

portrait a picture showing somebody's likeness. It can be head only or full length.

portrait bust a sculpture of a person's head and shoulders.

print a work on paper that may be produced many times. Wet paper is rolled over a metal or wooden plate on which a design has been cut and covered with ink.

printing press a machine with rollers that puts pressure on wet paper as it is rolled over a printing block, forcing the paper to absorb the ink and be imprinted with the design.

quill a feather cut into a point at one end and dipped in ink to be used as a pen.

realism a style of painting in which the artist wants everything they paint to appear lifelike and believable.

restored painting any artwork that has been worked on after the artist's death in order to repair it and make it seem closer to how the original artist intended.

Romanticism a style of painting in which an artist's individual emotional response to a subject is valued over academic ability.

Salon the official place to exhibit your paintings as an artist in France. The exhibition was held every year.

sculpt, to sculpt to carve into wood or stone (or other materials) using a range of tools in order to produce a sculpture.

sculpture an artwork that is carved from a block of stone or wood, or is modelled in plaster. In contrast to a painting, a sculpture is three-dimensional.

self-portrait a portrait of the artist who painted it.

shading making areas of a drawing either darker or lighter.

sketch a drawing done in pencil, chalk or sometimes paint. Often sketches are produced quickly, and sometimes they form rough versions of subsequent artworks.

statue a full-length likeness of a person or animal, often made in bronze or stone, and often life-size or larger.

still life a painted arrangement of objects such as fruit and flowers, food and kitchenware.

stretcher a wooden frame used by an artist to stretch canvases over and to provide a flat surface on which to paint.

studio a room in which an artist keeps their materials and produces their works of art.

study an artwork done for practice or as an experiment.

symbol something that stands in for something else. For example, a dove carrying an olive branch is a symbol of peace.

Symbolism a form of painting that relies on substituting symbols for ideas.

tempera a form of paint made by mixing powdered colour with egg yolk. It was widely used before oil paint was invented around 1500.

watercolour a type of painting, mainly on paper, created using paints that can be thinned with water.

woodcut a kind of print in which designs are chiselled into wooden blocks before ink is applied and paper rolled over the surface.

PICTURE CREDITS

The full title for each artwork is given below. Also given, where possible, is the medium in which the artwork was made, and its dimensions in centimetres and metres, then inches and feet, height before width.

GIOTTO

page 8 Florentine School, detail of *The Renaissance Masters* showing Giotto, mid-16th century. Oil on wood, 66 x 210 (26 x 82 ¹¹⁄₁₆). Musée du Louvre, Paris, France. Photo Art Archive/Gianni Dagli Orti.
page 8 The Arena Chapel, Padua, Italy, 1303–05.
page 9 *The Flight into Egypt*. Fresco. Arena Chapel, Padua, Italy.
page 10 *The Adoration of the Magi* (and detail). Fresco. Arena Chapel, Padua, Italy.
page 10 *Christ Giving His Blessing*. Fresco. Ceiling tondo, Arena Chapel, Padua, Italy.
page 11 *Crucifix*, 1290 or 1300. Wood panel. Sacristy, Santa Maria Novella, Florence, Italy.

LEONARDO DA VINCI

page 12 *Self-Portrait*, 1512–15. Red chalk, 33.3 x 21.3 (13 ⅛ x 8 ⅜). Royal Library, Turin, Italy.
page 12 Design for a wing of a flying machine, c. 1482. Biblioteca Ambrosiana, Codice Atlantico, 858r, Milan, Italy.
page 13 Studies of the foetus in the womb, weight and optics, c. 1513. The Royal Collection, Windsor Castle, England, 19102r.
page 13 Studies of the bones and musculature of the arm, c. 1511. The Royal Collection, Windsor Castle, England, 19000v.
page 14 *The Virgin of the Rocks*, c. 1478. Oil on panel transferred to canvas, 199 x 122 (78 ¼ x 48). Musée du Louvre, Paris, France.
page 14 *The Last Supper*, c. 1495–98. Tempera wall panel, 460 x 880 (181 ⅛ x 346 ⁷⁄₁₆). Santa Maria delle Grazie, Milan, Italy.
page 15 *Mona Lisa*, c. 1503–06. Oil on panel, 77 x 53.5 (30 ¼ x 21). Musée du Louvre, Paris, France.

ALBRECHT DÜRER

page 16 *Self-Portrait at 29*, 1500. Panel, 67 x 48.9 (26 ⅜ x 19 ¼). Alte Pinakothek, Munich, Germany.
page 16 *Adam and Eve*, 1504. Engraving, 24.8 x 19.2 (9 ¾ x 7 ½). Metropolitan Museum of Art, New York, USA.
page 17 *The Feast of the Rose Garlands*, 1506. Oil on panel, 162 x 194.5 (63 ¾ x

76 ⁹⁄₁₆). National Gallery, Prague, Czech Republic.
page 18 *Hare*, 1502. Watercolour and gouache on paper, 25 x 22.5 (9 ⅞ x 8 ⅞). Albertina, Vienna, Austria. Photo Austrian Archive/Scala, Florence.
page 19 *The Rhinoceros*, 1515. Pen and ink drawing, 27.4 x 42 (10 ¹³⁄₁₆ x 16 ⁹⁄₁₆). Department of Prints and Drawings, British Museum, London, England.

MICHELANGELO

page 20 Woodcut portrait of Michelangelo from Giorgio Vasari, *Lives of the Artists*, Florence, Italy, 1568.
page 20 Sistine Chapel ceiling, 1508–12. Fresco, 13.7 x 39 m (45 x 138 ft). Vatican, Italy.
page 21 *The Creation of Adam* (detail). Sistine Chapel, Vatican, Italy.
page 21 Study for *The Libyan Sibyl* on the Sistine Chapel ceiling, c. 1510. Red chalk on buff paper, 28.9 x 21.4 (11 ⅜ x 8 ⁷⁄₁₆). Metropolitan Museum of Art, New York, USA.
page 21 *The Libyan Sibyl* (detail). Sistine Chapel, Vatican, Italy.
page 22 *David*, 1501–04. Marble, height 408 (160 ⅝). Galleria dell'Accademia, Florence, Italy.
page 23 *The Last Judgment*, 1536–41. Fresco. Sistine Chapel, Vatican, Italy.

RAPHAEL

page 24 *Self-Portrait*, c. 1506. Oil on wood, 47.5 x 33 (18 ½ x 13). Galleria degli Uffizi, Florence, Italy.
page 24 *The Madonna and Child Enthroned with St John the Baptist and St Nicholas of Bari (The Ansidei Madonna)*, c. 1505. Oil on poplar, 209.6 x 148.6 (82 ½ x 58 ½). National Gallery, London, England. Photo Bridgeman Art Library, London.
page 25 *The School of Athens* (detail), 1510–11. Fresco. Raphael Stanze, Stanza della Segnatura, Vatican, Italy.
page 26 *Pope Julius II*, 1511–12. Oil on poplar, 108.7 x 81 (42 ¹³⁄₁₆ x 31 ⅞). National Gallery, London, England. Photo Bridgeman Art Library, London.
page 27 *The Deliverance of St Peter from Prison*, 1513–14. Fresco. Raphael Stanze, Stanza di Eliodoro, Vatican, Italy.
page 27 *The Triumph of Galatea*, c. 1512–14. Fresco, 295 x 225 (116 x 88 ½). Villa Farnesina, Rome, Italy.

TITIAN

page 28 *Self-Portrait*, c. 1550–62 . Oil on canvas, 96 x 75 (37 ¹³⁄₁₆ x 29 ½). Gemälde-galerie, Staatliche Museen, Berlin, Germany.
page 28 *The Emperor Charles V on Horseback in Mühlberg*, 1548. Oil on canvas, 332 x 279 (130 ¾ x 109 ⅞). Museo del Prado, Madrid, Spain.
page 29 *Portrait of Ranuccio Farnese*, 1542. Canvas, 89.7 x 73.6 (35 ⁵⁄₁₆ x 29). National Gallery of Art, Washington, D.C., USA.
page 30 *The Pesaro Altarpiece*, 1519–26.

Canvas, 478 x 266.5 (188 ³⁄₁₆ x 104 ¹⁵⁄₁₆). Santa Maria Gloriosa dei Frari, Venice, Italy.
page 31 *Bacchus and Ariadne*, 1520–23. Oil on canvas, 176.5 x 191 (69 ½ x 75 ³⁄₁₆). National Gallery, London, England. Photo Bridgeman Art Library, London.

HANS HOLBEIN THE YOUNGER

page 32 *Self-Portrait*, 1543. Miniature. Watercolour on playing card or vellum, diameter 3.5 (1 ⅜). Wallace Collection, London, England.
page 32 *Sir Thomas More*, 1527. Oil on panel, 74.9 x 60.3 (29 ½ x 23 ¾). Frick Collection, New York, USA.
page 33 *Portrait of Jean de Dinteville and Georges de Selve (The Ambassadors)*, 1533. Oil on oak, 207 x 209.5 (81 ½ x 82 ½). National Gallery, London, England. Photo Bridgeman Art Library, London.
page 34 *King Henry VIII*, c. 1536. Oil on panel, 28 x 20 (11 x 7 ⅞). Museo Thyssen-Bornemisza, Madrid, Spain.
page 35 *Portrait of Mary Wotton, Lady Guildford*, 1527. Black and coloured chalks, 55.2 x 38.5 (21 ¾ x 15 ³⁄₁₆). Kupferstichkabinett, Kunstmuseum Basel, Switzerland.

EL GRECO

page 36 *Self-Portrait*, 1584–1604. Oil on canvas, 59.1 x 46.4 (23 ¼ x 18 ¼). Metropolitan Museum of Art, New York, USA.
page 36 *The Burial of Count Orgaz*, 1586. Oil on canvas, 490 x 360 (192 ¹⁵⁄₁₆ x 141 ¾). Santo Tomé Church, Toledo, Spain.
page 37 *The Assumption of the Virgin*, 1577. Oil on canvas, 401 x 229 (157 ⅞ x 90 ³⁄₁₆). Art Institute of Chicago, Illinois, USA, Gift of Nancy Atwood Sprague in memory of Albert Arnold Sprague, 1906.99.
page 38 *The Adoration of the Shepherds*, c. 1612–14. Oil on canvas, 319 x 180 (125 ⁵⁄₁₆ x 70 ⅞). Museo del Prado, Madrid, Spain.
page 39 *Nobleman with his Hand on his Chest*, c. 1583–85. Oil on canvas, 81 x 66 (31 ⅞ x 26). Museo del Prado, Madrid, Spain.

CARAVAGGIO

page 40 Ottavio Leoni, *Portrait of Caravaggio* (detail), c. 1621. Red and black pencil. Biblioteca Marucelliana, Florence, Italy.
page 40 *The Cardsharps*, c. 1594. Oil on canvas, 94.2 x 130.9 (37 ⅛ x 51 ⅝). Kimbell Art Museum, Fort Worth, Texas, USA.
page 41 *The Supper at Emmaus*, 1601. Oil and egg on canvas, 141 x 196.2 (55 ½ x 77 ¼). National Gallery, London, England. Photo Bridgeman Art Library, London.
page 42 *The Inspiration of St Matthew*, 1602. Oil on canvas, 295.9 x 189.2 (116 ½ x 74 ½). Contarelli Chapel, San Luigi dei Francesi, Rome, Italy.
page 42 *The Conversion of St Paul*, 1600–01. Oil on canvas, 230 x 175 (90 ⁹⁄₁₆ x 68 ⅞). Cerasi Chapel, Santa Maria del Popolo, Rome, Italy.

page 43 *The Calling of St Matthew*, 1598–1600. Oil on canvas, 322 x 340 (126 ¾ x 133 ⅞). Contarelli Chapel, San Luigi dei Francesi, Rome, Italy.

ARTEMISIA GENTILESCHI

page 44 *Self-Portrait as a Female Martyr (Female Martyr)*, c. 1615. Oil on panel, 31.8 x 24.8 (12 ½ x 9 ¾). Private collection.
page 44 *Judith Slaying Holofernes*, c. 1620. Oil on canvas, 199 x 163 (78 ⅜ x 64 ³⁄₁₆). Uffizi Gallery, Florence, Italy.
page 45 *Self-Portrait as the Allegory of Painting (La Pittura)*, 1638–39. Oil on canvas, 96.5 x 73.7 (38 x 29). The Royal Collection © 2008, Her Majesty Queen Elizabeth II.
page 46 *Madonna and Child*, 1610–11. Oil on canvas, 116.5 x 86.5 (45 ⅞ x 34). Galleria Spada, Rome, Italy.
page 47 *Judith and her Maidservant*, c. 1625–27. Oil on canvas, 182.8 x 142.2 (72 x 56). Detroit Institute of Arts, USA, Gift of Mr Leslie H. Green.

GIAN LORENZO BERNINI

page 48 *Self-Portrait as a Young Man*, c. 1620. Oil on canvas. Galleria Borghese, Rome, Italy.
page 48 Detail of *The Fountain of the Four Rivers* showing Rio de la Plata, 1648–51. Granite, marble and travertine. Piazza Navona, Rome, Italy. Photo Scala, Florence.
page 49 *Sketch of Cardinal Scipione Borghese* (detail). Black chalk on card, 25.3 x 18.4 (9 ¹⁵⁄₁₆ x 7 ¼). Pierpont Morgan Library, New York, USA.
page 49 *Bust of Cardinal Scipione Borghese*, 1632. Marble, height 78 (30 ¹¹⁄₁₆). Galleria Borghese, Rome, Italy.
page 49 *Caricature of Cardinal Scipione Borghese*. Biblioteca Vaticana, Rome, Italy.
page 50 *Ecstasy of St Teresa*, c. 1650. Marble, height c. 350 (137 ¾). Cornaro Chapel, Santa Maria della Vittoria, Rome, Italy.
page 51 *The Goat Amalthea with the Infant Jupiter and a Faun*, 1609. Marble. Galleria Borghese, Rome, Italy. Photo Scala, Florence – courtesy of the Ministero Beni e Att. Culturali.
page 51 *David*, 1623–24. Marble. Galleria Borghese, Rome, Italy. Photo Scala, Florence – courtesy of the Ministero Beni e Att. Culturali.

DIEGO VELÁZQUEZ

page 52 *Self-Portrait*, c. 1640. Oil on canvas, 45.8 x 38 (18 ¹⁄₁₆ x 14 ¹⁵⁄₁₆). Museo de Bellas Artes de San Pío V, Valencia, Spain.
pages 52 and 53 *Las Meninas (Velázquez and the Royal Family)* (and detail), 1656–57. Oil on canvas, 318 x 276 (125 ³⁄₁₆ x 108 ¹¹⁄₁₆). Museo del Prado, Madrid, Spain.
page 54 *Portrait of Pope Innocent X*, 1650. Oil on canvas, 140 x 120 (55 ⅝ x 47 ¼). Galleria Doria-Pamphilj, Rome, Italy.
page 55 *The Waterseller of Seville*, c. 1619–20. Oil on canvas, 106.7 x 81 (42 x 31 ⅞). Wellington Museum, Apsley House, London, England.

Rembrandt

page 56 *Self-Portrait*, 1658. Oil on canvas, 133.6 x 103.8 (52⅝ x 40⅞). Frick Collection, New York, USA, Henry Clay Frick Bequest 1906.1.97.
page 56 *Rembrandt's Mother*, 1628. 6.7 x 6.4 (2⅝ x 2½). Pierpont Morgan Library, New York, USA.
page 57 *Hendrickje Bathing (A Woman Bathing in a Stream)*, 1654. Oil on oak, 61.8 x 47 (24⁵⁄₁₆ x 18½). National Gallery, London, England. Photo Bridgeman Art Library, London.
page 58 *Self-Portrait in Oriental Attire*, 1631. Panel, 66.5 x 52 (26³⁄₁₆ x 20½). Musée du Petit Palais, Paris, France, inv. no. 925.
pages 58 and 59 *The Night Watch (The Militia Company of Frans Banning Cocq)* (and detail), 1642. Oil on canvas, 363 x 437 (142¹⁵⁄₁₆ x 172¹⁄₁₆). Rijksmuseum, Amsterdam, Netherlands.

Francisco de Goya

page 60 *Self-Portrait in the Studio*, 1790–95. Oil on canvas, 42 x 28 (16½ x 11). Real Academia de Bellas Artes de San Fernando, Madrid, Spain.
page 60 *The Dream of Reason Produces Monsters*, Capricho 43, 1797–98. Etching and aquatint, 21.6 x 15.2 (8½ x 5⅞). British Museum, London, England.
page 61 *The Third of May 1808*, 1814. Oil on canvas, 268 x 347 (105½ x 136⅝). Museo del Prado, Madrid, Spain.
page 62 *The Family of Charles IV*, 1800–01. Oil on canvas, 280 x 336 (110¼ x 132⁵⁄₁₆). Museo del Prado, Madrid, Spain.
page 63 *Manuel Osorio Manrique de Zuñiga* (and detail), c. 1788. Oil on canvas, 127 x 101 (50 x 39¾). Metropolitan Museum of Art, New York, USA.

Jacques-Louis David

page 64 *Self-Portrait*, 1794. Oil on canvas, 81 x 64.1 (31⅞ x 25¼). Musée du Louvre, Paris, France.
page 64 *Portrait of Comte Henri-Amédé de Turenne*, 1816. Oil on panel, 112 x 81 (44 x 31⅞). Ny Carlsberg Glyptotek, Copenhagen, Denmark.
page 65 *Napoleon Crossing the Saint Bernard Pass, 20th May, 1801–02*. Oil on canvas, 246 x 321 (96⅞ x 126⅜). Kunsthistorisches Museum, Vienna, Austria.
page 66 *The Oath of the Horatii*, 1784. Oil on canvas, 329.9 x 424.8 (129⅞ x 167¼). Musée du Louvre, Paris, France.
page 67 *The Death of Marat*, 1793. Oil on canvas, 161.9 x 124.8 (63¾ x 49). Musées Royaux des Beaux-Arts, Brussels, Belgium.

J.M.W. Turner

page 68 *Self-Portrait* (detail), c. 1799. Oil on canvas, 74.3 x 58.5 (29¼ x 23¹⁄₁₆). Tate, London, England, 2006, N00458.
page 68 *Fountains Abbey: Huby's Tower from the Chapel of the Nine Altars* from the *Tweed and Lakes* sketchbook, 1797. Pencil and watercolour, 36.8 x 26.2 (14½ x 10¹⁵⁄₁₆). Turner Collection, Tate, London, England, D01082.
page 69 *Dido Building Carthage*, 1815. Oil on canvas, 155.5 x 230 (61¼ x 90⁹⁄₁₆). National Gallery, London, England. Photo Bridgeman Art Library, London.
page 70 *Venice: a Storm*, 1840. Watercolour, 21.8 x 31.8 (8⁹⁄₁₆ x 12½). British Museum, London, England.
page 70 Opening from the *Walmer Ferry* sketchbook, c. 1815. 16 x 11.2 (6⁵⁄₁₆ x 4⁷⁄₁₆). Turner Collection, Tate, London, England, D10658.
page 71 *Calais Pier, with French Poissards preparing for Sea: an English Packet Arriving*, 1803. Oil on canvas, 172 x 240 (67¹¹⁄₁₆ x 94½). National Gallery, London, England. Photo Bridgeman Art Library, London.
page 71 *Snow Storm: Steam Boat off a Harbour's Mouth making Signals in Shallow Water, and going by the Lead. The Author was in this Storm on the Night the Ariel left Harwich*, exhibited 1842. Oil on canvas, 91.4 x 121.9 (36 x 48). Tate, London, England, N00530.

Eugène Delacroix

page 72 *Self-Portrait in a Green Waistcoat*, c. 1837. Oil on canvas, 65 x 54.5 (25⁹⁄₁₆ x 21⅞). Musée du Louvre, Paris, France.
page 72 *Liberty Leading the People*, 1830. Oil on canvas, 260 x 325 (102⅜ x 128). Musée du Louvre, Paris, France.
page 73 *The Barque of Dante*, 1822. Oil on canvas, 189 x 246 (74⁷⁄₁₆ x 96⅞). Musée du Louvre, Paris, France.
page 74 *The Death of Sardanapalus*, 1827–28. Oil on canvas, 395 x 495 (155½ x 194⅞). Musée du Louvre, Paris, France.
page 75 *The Arrival at Meknes* from the *Moroccan* sketchbooks, 1832. Watercolour and pencil, each page 19.3 x 12.7 (7⅝ x 5). Musée du Louvre, Paris, France.
page 75 *The Lion Hunt*, 1855. Oil on canvas, 175 x 359 (68¾ x 141⁵⁄₁₆), originally 270 x 359 (106⁵⁄₁₆ x 141⁵⁄₁₆). Musée des Beaux-Arts, Bordeaux, France.

Édouard Manet

page 76 *Self-Portrait with a Palette*, c. 1879. Oil on canvas, 83 x 67 (32¹¹⁄₁₆ x 26⅜). Private collection.
pages 76 and 77 *A Bar at the Folies-Bergère* (and detail), 1881–82. Oil on canvas, 96 x 130 (37¹³⁄₁₆ x 51³⁄₁₆). Samuel Courtauld Trust, Courtauld Institute of Art Gallery, London, England.

page 78 *The Fifer*, 1866. Oil on canvas, 160 x 97.5 (63 x 38¼). Musée d'Orsay, Paris, France.
page 79 *The Railroad*, 1872–73. Oil on canvas, 93 x 114 (36⅝ x 44⅞). National Gallery of Art, Washington, D.C., USA.

Claude Monet

page 80 *Self-Portrait*, c. 1915–17. Oil on canvas, 70 x 55 (27⁹⁄₁₆ x 21⅝). Musée d'Orsay, Paris, France, Gift of Georges Clemenceau, 1927.
page 80 *Regattas at Argenteuil*, 1874. Oil on canvas, 48 x 75 (18⅞ x 29½). Musée d'Orsay, Paris, France.
page 81 *Impression: Sunrise*, 1873. Oil on canvas, 48 x 63 (19 x 24⅜). Musée Marmottan, Paris, France.
page 82 *La Gare Saint-Lazare, Arrival of a Train*, 1877. Oil on canvas, 81 x 101 (31⅞ x 39¾). Fogg Art Museum, Harvard University, Cambridge, Massachusetts, USA.
page 82 *Wheatstacks (End of Summer)*, 1890–91. Oil on canvas, 60 x 100 (23⅝ x 39⅜). Art Institute of Chicago, USA, Arthur M. Wood in memory of Pauline Palmer Wood (1985.1103).
page 82 *Wheatstacks (Sun in the Mist)*, 1891. Oil on canvas, 65 x 100 (25⅝ x 39⅜). The Minneapolis Institute of Arts, USA, Gift of Ruth and Bruce Dayton, The Putnam Dana McMillan Fund, The John R. Van Derlip Fund, The William Hood Dunwoody Fund, The Ethel Morrison Van Derlip Fund, Alfred and Ingrid Lenz Harrison, and Mary Joann and James R. Jundt (93.20).
page 83 *Water Lilies*, 1907. Oil on canvas, diameter 81 (31⅞). Musée d'Art Moderne de Saint-Etienne, Saint-Etienne, France.

Vincent Van Gogh

page 84 *Self-Portrait with Bandaged Ear* (detail), 1889. Oil on canvas, 60.5 x 50 (23¹³⁄₁₆ x 19¹¹⁄₁₆). The Samuel Courtauld Trust, Courtauld Institute of Art Gallery, London, England.
page 84 *The Potato Eaters*, 1885. Oil on canvas, 82 x 114.3 (32¼ x 45). Van Gogh Museum, Amsterdam, Netherlands.
page 85 *The Artist's Bedroom at Arles*, 1888. Oil on canvas, 72 x 90 (28¼ x 35½). Van Gogh Museum, Amsterdam, Netherlands.
page 86 *Portrait of Doctor Gachet*, 1890. Oil on canvas, 66 x 57 (26 x 22⁷⁄₁₆). Private collection.
page 86 *Fourteen Sunflowers in a Vase*, 1888. Oil on canvas, 93 x 73 (36⅝ x 28¾). National Gallery, London, England. Photo Bridgeman Art Library, London.
page 87 *The Starry Night*, 1889. Oil on canvas, 73.7 x 92.1 (29 x 36¼). Museum of Modern Art, New York, USA.

First published in the United Kingdom in 2008 by Thames & Hudson Ltd, 181A High Holborn, London WC1V 7QX

www.thamesandhudson.com

© 2008 Thames & Hudson Ltd, London

British Library Cataloguing-in-Publication Data

A catalogue record for this book is available from the British Library

ISBN 978-0-500-23853-0

Printed and bound in China by C&C Offset Printing Co. Ltd.